WILLIAM BECKMAN

FRYE ART MUSEUM

in association with the University of Washington Press

Seattle and London

WILLIAM BECKMAN

PUBLISHERS

Frye Art Museum
704 Terry Avenue
Seattle, WA 98104
www.fryeart.org

Seven Bridges Foundation
114 John Street
Greenwich, CT 06831

SEVEN |||| BRIDGES

AUTHOR Carl Belz
EDITORS Richard V. West, Debra Byrne, and Kathleen Brady
DESIGNER Beth Koutsky

Printed in China

Distributed by University of Washington Press
P.O. Box 50096
Seattle, Washington 98145
www.washington.edu/uwpress/

ISBN 0-295-98289-6
Library of Congress Control Number: 2002109004

CONTENTS

3 **ACKNOWLEDGMENTS**

Richard V. West and Debra J. Byrne

5 **WILLIAM BECKMAN**

Carl Belz

5 INTRODUCTION

11 BOXES

19 DIANA

31 COUPLES

43 SELF PORTRAITS

55 LANDSCAPES

81 DRAWINGS AND STUDIES

93 PORTRAITS AND FIGURES

106 **SELECTED BIOGRAPHY**

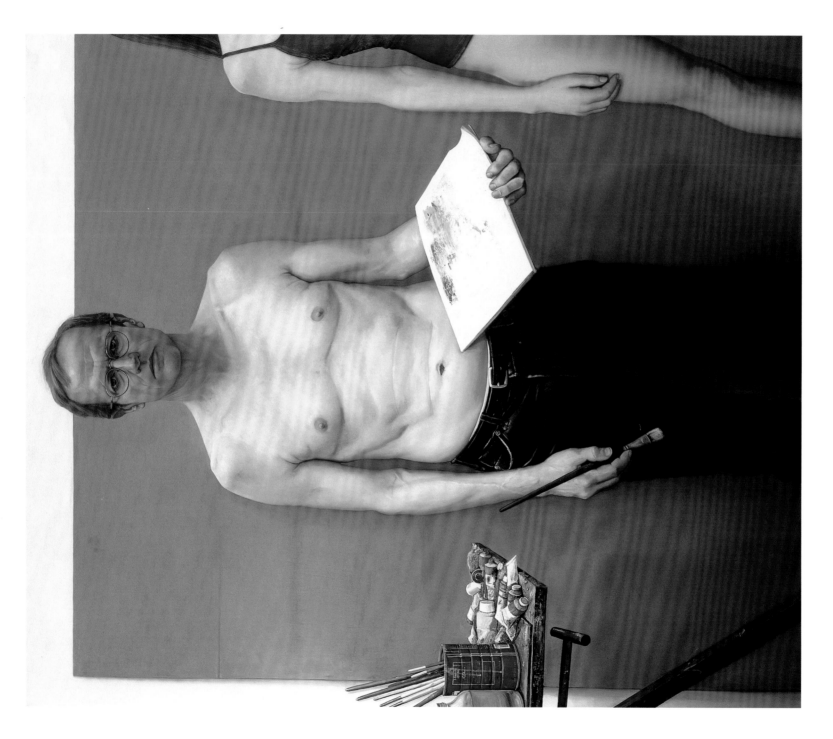

PLATE 1

STUDIO II 2000–2001

Oil on panel, 78 5/8 x 66 in.
Courtesy of Forum Gallery

ACKNOWLEDGMENTS

THIS EXHIBITION AND PUBLICATION ARE THE RESULT OF THE GENEROUS CONTRIBUTIONS OF MANY people who recognized the value of displaying and documenting the works of William Beckman. Robert and Cheryl Fishko, Director and Manager, respectively, of Forum Gallery, New York and Los Angeles, deserve special attention for their commitment, support, and efforts at every stage of the project from initiation to completion. We also thank Richard and Molly Mckenzie of the Seven Bridges Foundation, Greenwich, Connecticut for their unwavering support of this publication, which was coordinated and edited by Kathleen Brady of Forum Gallery with calm and good cheer. We are also deeply indebted to the keen insight and sensitivity of Carl Belz, whose essay will continue to inspire and inform our experience and knowledge of Beckman's art. The contributions of those individuals and institutions who willingly loaned their works and images have been invaluable. Thanks to Beth Koutsky for the handsome design of this publication, and to the Frye Art Museum staff for their dedication to excellence. Finally, and most importantly, the artist deserves our admiration and gratitude for his unflinching vision of the human condition, which he delivers with extraordinary skill and style.

Richard V. West

Executive Director
Frye Art Museum

Debra J. Byrne

Director for Curatorial Affairs and Exhibitions
Frye Art Museum

SEVEN BRIDGES FOUNDATION WAS ESTABLISHED BY RICHARD AND MOLLY MCKENZIE FOR THE exhibition and preservation of works of art in a surrounding natural setting. The foundation houses a unique collection of modern and contemporary representational art in its Gallery building and on landscaped grounds. The Gallery, completed in 1994, presently holds over 200 paintings by Odd Nerdrum, Richard Maury, Will Wilson, Christian Vincent, William Beckman, Cynthia Schaefer, Michael Bergt, Eric Goulder, Sean Henry and others. Sculptures by Henry Schiowitz, Cynthia Schaefer, Michael Bergt, Eric Goulder, Sean Henry and others are installed on the grounds. Seven Bridges Foundation is located in Greenwich, Connecticut and is open, by appointment, to museum groups, scholars, artists and students.

3

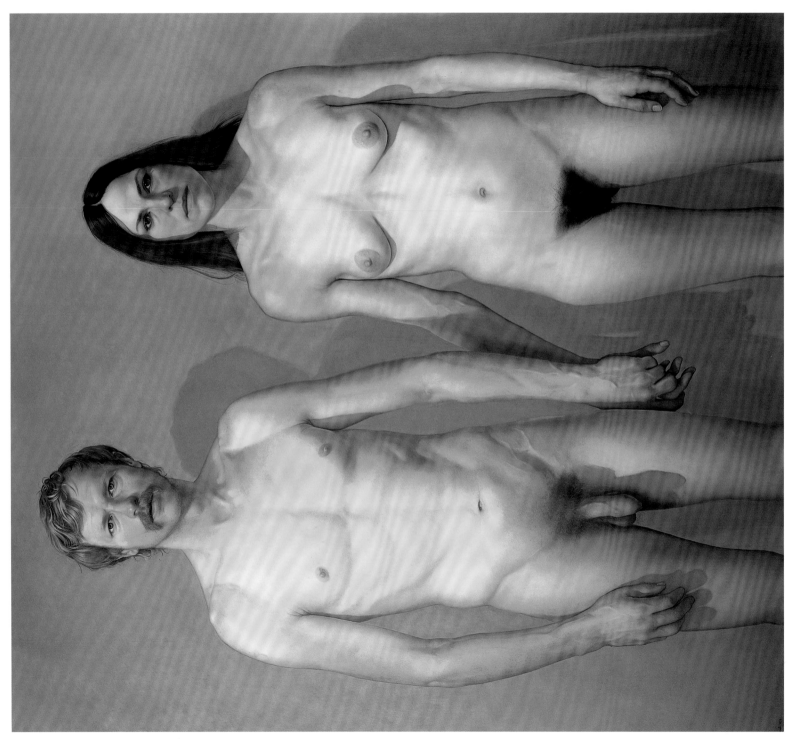

PLATE 2

DOUBLE NUDE 1977–1978

Oil on panel, 70 x 58 in.
Collection of Rose Art Museum,
Brandeis University, Herbert W. Plimpton

4

WILLIAM BECKMAN

INTRODUCTION

Carl Belz

I'VE BEEN PRIVILEGED TO KNOW WILLIAM BECKMAN FOR OVER TWENTY YEARS, since his 1979 visit to the Rose Art Museum, where I was director at the time. He and his then-wife Diana had come to see the first of his couples paintings, *Double Nude* (1978) PLATE 2, which had recently been acquired by a collector friend and was at the museum on a loan basis. Prior to his arrival I wondered why he wanted to see his own painting—surely, he must have known what it looked like. He told me he had worked on it for over a year, that it had left the studio shortly after completion and was quickly sold, and that he wanted to see how he felt about it after he'd had time to distance himself from the effort he'd devoted to it. I could appreciate that: it was as though

Carl Belz is Director Emeritus of the Rose Art Museum, Brandeis University, Waltham, Massachusetts, and is currently Managing Editor of Art New England magazine, which is based in Brighton, Massachusetts.

he'd given arduous birth to the picture and then had no opportunity to look at what he'd brought forth. How arduous it must have been I came to appreciate later when I learned that Beckman typically works and reworks his pictures, scrapes and sands them, his models standing at one stage, seated at another, alternately clothed and naked while the spaces they occupy undergo equally radical changes during the process. Resolving an image, in other words, is never just a matter of time-consuming execution, of the artist covering the surface, top to bottom, left to right, by rendering what's before his eyes. "I couldn't paint that way, I don't know how one could visual-ize the thing all the way through without playing one area off another. For me, a great deal of the thrill of painting is just realizing it, getting to the point where you see it for the first time. After I work on a painting for a month or two, I can't resist bringing one spot up, realizing one spot, knowing perfectly well that that spot will have to be brought up again once I start bringing up other spots. So I'll be bringing up areas throughout the picture, and that's when it starts to grow and to dictate some of the emotion, some of the final image and the final response."

The Beckman paintings I'd seen before 1979 in one or another of the realist exhibitions that were ubiquitous at the time had astonished me with their gripping

and penetrating detail. They reminded me of the Northern Renaissance masters I'd studied and admired—and, as it turned out, that he'd studied and admired as well—but I probably should have realized at our first meeting that his realism was leagues removed from the merely factual rendering that characterized so much contemporary work in the genre, most of it photo-based, because, in person, neither he nor Diana looked the way they looked in *Double Nude*. They were in no way as intense in appearance, nor, even more surprising, nearly as tall—not over six feet, as I expected from the scale of the picture. Which got me to thinking more and more about realist-type painting—abstraction had always been my first love—and I was spurred in that direction when I received a note from Bill asking me if I would consider doing an exhibition of his work and Gregory Gillespie's, as the two had been friends for many years, regularly visited one another's studios, and shared many of the same ambitions for their art. As artists often do, they set the qualitative bar for one another—first as painters, only secondarily as realists, a troublesome label to both—and their exhibition, which took place in 1984, in turn set a bar for me.

Realism. For Beckman, the label was more acceptable in the late sixties and seventies, when he was evolving his vision, than it is now. Group exhibitions provided opportunities

to get the work seen in a range of venues and returned realism to the art discourse after it had been in eclipse for nearly two decades following World War II. With increasing maturity, he is less comfortable with the label, as well he should be, for it is limiting and fails to account for the full spectrum of thought and feeling that comprise his art—for the many ways he's found to bond form and content. The essays that follow—*Boxes, Diana, Couples, Self Portraits, Landscapes,* and *Drawings and Studies*—cluster the work according to subject matter, and in them I try to describe those bonds and articulate their expressive significance. If the realist label survives them, I only hope it will in the end have come to connote the work's deep embodiment of lived human experience—and particularly the *modern* experience—for that's the substance of serious art.

Clustering the work according to subjects accounts for a large majority of the pictures but not all—not *Diana and Deidra* PLATE 14, or *Classical Woman* PLATE 80, not the portraits of his father and mother PLATES 77 and 78, or those of Deborah Schneider, the model in *White Painting* PLATE 26, and Jeannie Zetterstrand, whom we see in *Overcoats* FRONT COVER, and, finally, not the paintings of his artistic ally, Gregory Gillespie PLATES 85, 86 AND 87. Which is not to say they're anomalous, far from it, for each,

whether as spouse or parent, partner or friend, is the product of an extended relationship between artist and subject, and such relationships—including his ties to the land—inspire the content in all of Beckman's work. So I see these examples as reinforcing the otherwise dominant groupings, and those, in turn, I see as formal guides that enable us to grasp the unfolding shape of his artistic thought. Significantly, none of the groupings constitutes a series in the familiar sense; that is, a theme and its variations developed through a continuous run of images. Instead, they are generally interspersed and periodically interrupted, and that's because relationships, like the volatile thoughts and feelings they subsume, are necessarily configured only when we find ourselves in their unpredictable grip. Beckman is as responsive to those situations as he is tenacious in exploring them, and his art is accordingly slow—because it offers such visual abundance, to be sure, but equally because its understandings are so deeply felt and considered. To respond in kind is to be just as deeply rewarded.

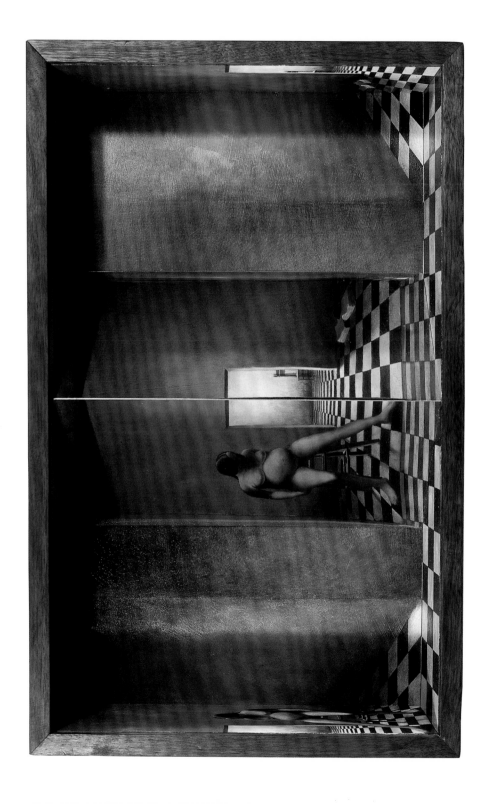

PLATE 3

DIANA PREGNANT #4 1969

Wood, oil, mirrors, 14 x 34 x 7 1/4 in.

Private Collection

BOXES

BECKMAN'S EARLIEST MATURE PAINTINGS CONSIST OF A SERIES OF BOXES executed between 1967 and 1970 that depict solitary female nudes within imaginary domestic interiors whose floors, often tiled in black and white to resemble 17th century Dutch interiors, recede dramatically into fictive space. He'd studied the Northern European masters in art history courses at the University of Iowa, where he earned his master's degree in 1968, but the box housings were additionally inspired by the art of that moment: "I found three boxes in a dump while out running one day and dragged them home. They were just boxes that some hardware store had thrown out; they were closed on five sides and had glass on the sixth, and they just sat in my studio for about six months until I started putting drawings on the back wall and polished aluminum on the side walls—a carry-over from minimalism, which was hot at the time, and I liked its idea of cutting out everything until you see only what you need to see. From there I started making my own boxes out of hardwood, changing the medium to oil and the construction to fit my imagined perspectives. The boxes were also very conceptual, extremely sparse and extremely bare, and they kept you away from them. The figures are either turned to the back, or they're in profile or three-quarter view—none of them come right at you, because they're physically and spiritually enclosed in that space. They're sort of like worlds unto themselves."

Miniature worlds, we might add, for the images are small enough to imagine holding them in our hands and experiencing them in solitude—intimately, as we might hold the drawings the artist first placed at the back of the boxes, or as we might hold manuscript illuminations, or even photographs—all the while becoming privately absorbed in them, just as, turned away from us, the figures themselves are privately absorbed. In this they remind us of their solemn counterparts in Jan Vermeer's (1632–1675) paintings whose tiled floors have already been called to mind. The glass fronts at once enclose and distance these worlds, as Beckman says, but they also establish our relationship to the figures within them, a relationship that is necessarily remote and otherworldly—though transparent, the fronts become barriers to the boxes' initial invitation to intimacy with the figures and to the attendant urge to know them. Intimacy is also summoned in the close rendering of the figures, making them seem palpably immediate, but our relationship to them is again thwarted, in this case by their surrounding walls, some of which are painted, while others are simply mirror-like reflections. As we shift positions in viewing the boxes, the figures accordingly appear, disappear, and occasionally become duplicated, leaving us in doubt about which are

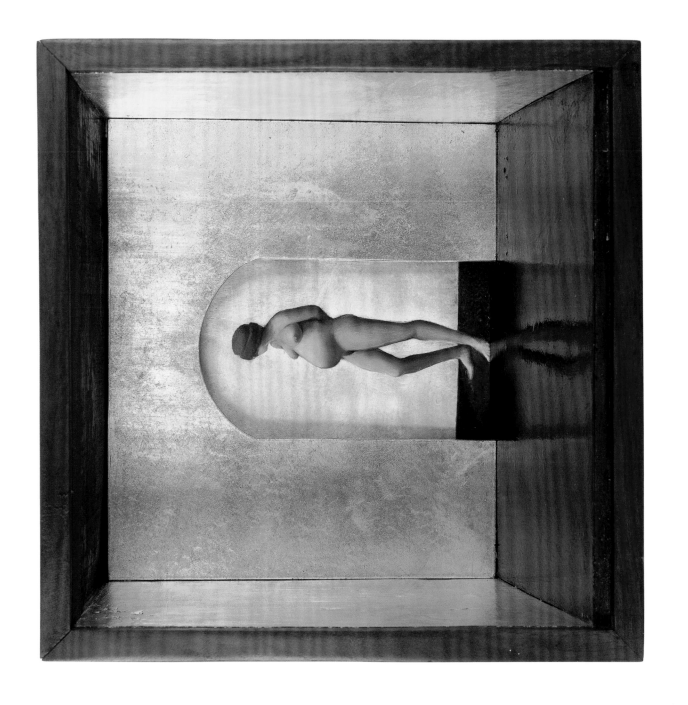

PLATE 4

DIANA PREGNANT #2 1968

Wood, oil, gold leaf, 12 x 12 x 12 in.
Collection of Deidra Beckman Popkin

12

"real" and which merely illusions. As much as the figures thus become disembodied, the painting of them likewise becomes a mirage.

Beckman acknowledges that he was thinking about minimalism while creating the boxes, but he was surely thinking about realism as well, for it, too, was "hot" in the late sixties after being in the shadow of abstraction during the previous two decades. His realism here is as compelling as any around at that time, but his boxes, phantasmic in effect, undermine realism as much as they endorse it, reminding us that all art is "unreal" and, as such, abstract.

First shown in Chicago at the Richard Feigen Gallery in 1968, the boxes sold well and enabled Beckman, his wife Diana, and their infant daughter Deidra, to move to New York City, where he enjoyed his first solo exhibition—at the Hudson River Museum in 1969—and shortly thereafter joined the Allan Stone Gallery. In establishing his early reputation, the boxes also established an ongoing concern of Beckman's art, namely, its embrace of the Old Masters on the one hand and modernism on the other. But they had run their course by 1970, and their format was abandoned. "They were very intriguing to look at, but people were looking at them mostly for the constructions and the incredible perspectives I was getting. No one was looking at what was going on in the box—at the painting, the image."

Achieving a more direct relationship with the figurative image, however, didn't happen overnight. Affecting the transition were a diptych and triptych executed in 1971, the latter, called Family PLATE 8, comprising an allegory—unique in the oeuvre—of the artist's life up to that time. Beckman's parents occupy the "rural" panel on the right—he grew-up on a working farm in Maynard, Minnesota—his brother is the businessman holding a briefcase in the "urban" panel on the left, and the artist is seen shedding his clothes—and, presumably, the values of the two worlds surrounding him—in the central panel. He, Diana, and Diedra are aboard the Staten Island ferry, perhaps a reference to an earlier American realism, to John Sloan (1871–1951) and the "Ashcan School," but in any case an image of movement and change. Consistent with Beckman's thinking in preceding works, Family can be physically closed, reminding us of the boxes' distancing effect, while the triptych format and the appropriation of Piero della Francesca's (1416–1492) nude from the Baptism of Christ (1448–1450)—here signifying the artist's new life—naturally recall Renaissance altarpieces. In keeping with the boxes, too, most of the figures are self absorbed: only his mother on the right and the anonymous construction worker on the left make eye contact with us, quiet harbingers of potent images to come.

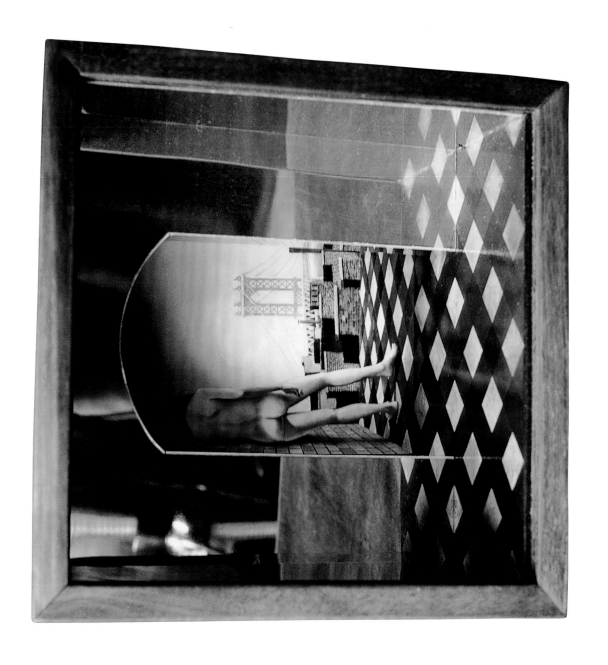

PLATE 5

MANHATTAN BRIDGE 1970

Walnut, oil, and polished aluminum, 12 x 12 x 9 in.

Private Collection

PLATE 6

DIANA DISROBING 1970

Wood, oil, mirrors, 13 7/8 x 17 5/8 x 7 1/4 in.

Collection of Rick and Monica Segal

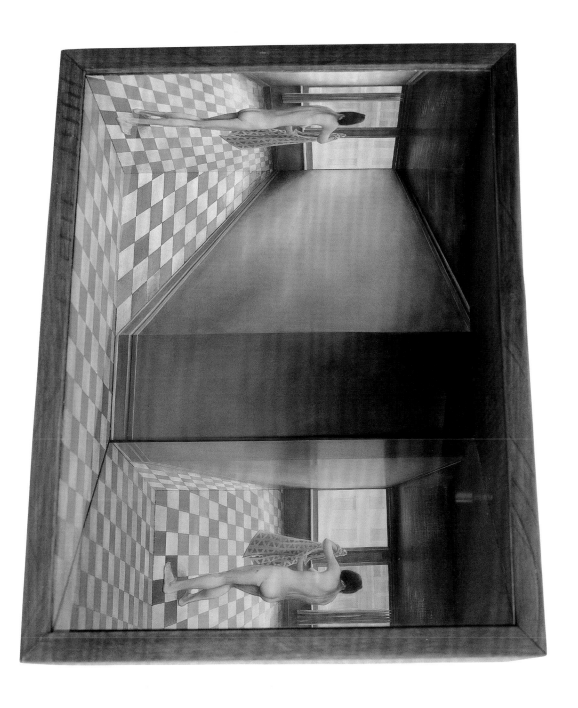

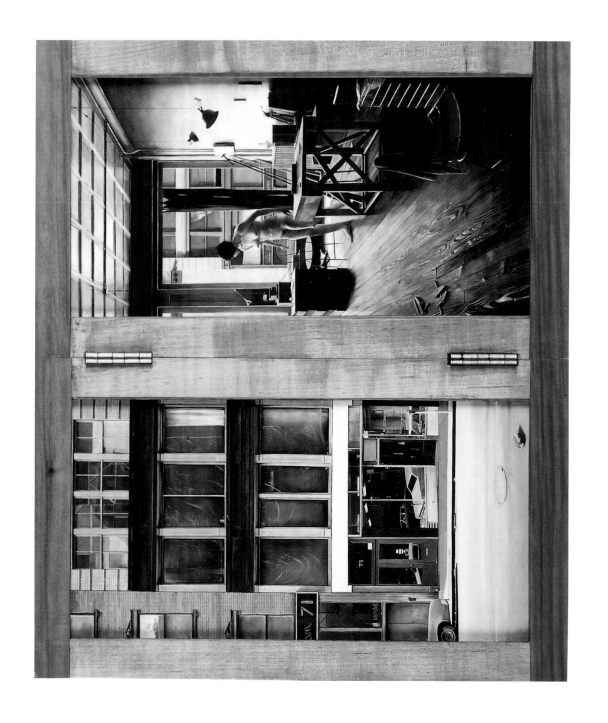

PLATE 7

EAST BROADWAY (MY LOFT) 1971

Diptych, oil on panel, 20 x 20 in.
Photography: Museum of Modern Art
Ludwig Foundation, Vienna

16

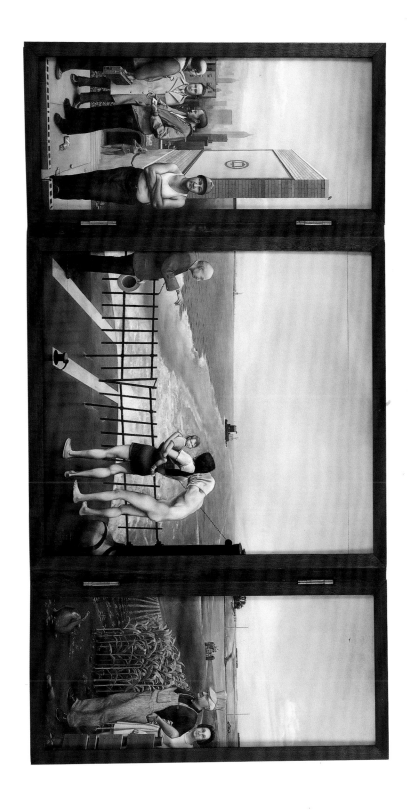

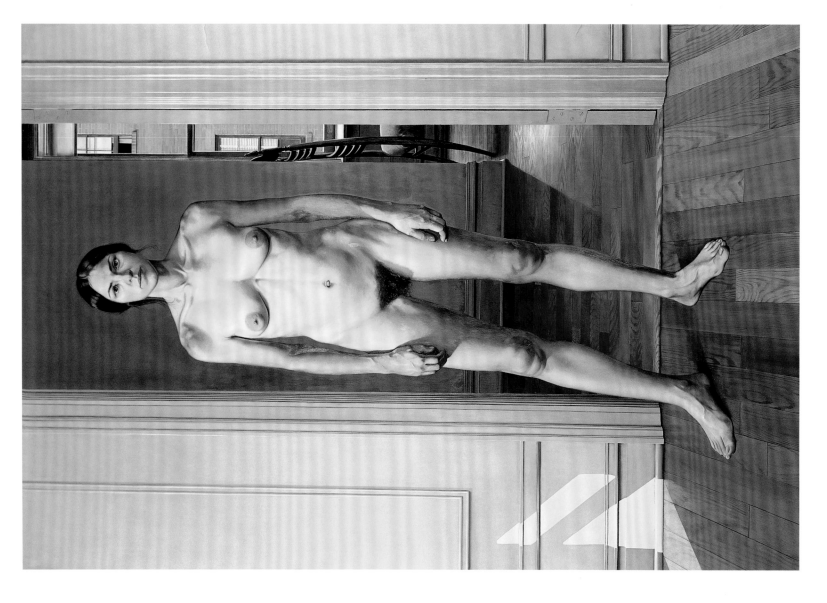

PLATE 9

DIANA #1 1971–1972

Oil on panel, 72 x 49 1/2 in.
Private Collection

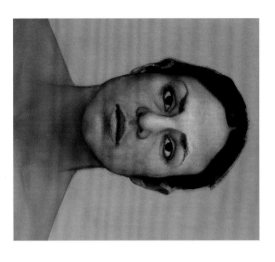

PLATE 10

DIANA #8 1983–1985

Oil on panel, 17 1/2 x 15 1/2 in.

Collection of UMB Bank

DIANA

DIANA #1 PLATE 9, WAS BEGUN IN 1971 AND COMPLETED THE FOLLOWING year; it was Beckman's first large scale figure painting, and it initiated a series of ten single images of Diana spanning nearly two decades—until the couple separated and were divorced at the end of the 1980s. With the exception of the final two panels, both completed from memory in 1990, all were done from direct observation and required countless hours of day-in, day-out patience and determination on the part of both artist and model. Worth pointing out here is the fact that both artist and model were, until the mid-1980s, serious distance runners who had met the challenge of the Boston and New York City marathons with impressive times of under three hours. "You're alone, an individual competing, if anything, against time and against exhaustion. You know you're going to be exhausted at the end. You know you're going to hurt, and you know that after twenty miles you're going to be in the kind of pain you'd never have to endure if you weren't in a race—but you keep going because there's that goal at the end and the realization that you'll have achieved the event. My kind of painting is like that. It's a lone effort, an individual effort. You contain yourself, but you can still achieve the goal of expressing and communicating your emotions." You get the picture: The artist and the art are tightly entwined.

With the exception of *Diana #6* (1983–85) PLATE 16, and *Diana #3* (1976) PLATE 13, all of the figures are confrontational, the model virtually staring us down—a clear sign of Beckman's abandonment of the absorptive mode for his figures in the boxes and his strategy for getting us to *look* at the image, by giving us no other choice than to engage. Granted, we're given other things to look at in the first three pictures, a polished floor, an oriental carpet, a plant, drapery, a glimpse through a door or window—evidence, in each case, of the self-taught artist mastering his technique and his ongoing preoccupation with motifs inspired by the Old Masters—but the trappings are invariably eclipsed by the figure who dominates the space and defies our gaze with her own. Beginning with *Diana #4* (1981) PLATE 11, those trappings yield to fields of color that abstract the space the model occupies, isolating her and formally pressing her toward us, and our encounter is additionally intensified in the pictures following

Diana #4 by the fact that she is cropped, situated ever closer to the space *we* occupy. As the series evolves, then, our options for looking become increasingly limited: we either engage the proffered human encounter or, like the figure in *Diana #10* PLATE 19, *we look away.*

Like chapters in a novel—though not conceived as such, for Beckman is a painter, not a narrator—these pictures image one person over a twenty-year span, but who is that person? We want to say she is Diana Moore, the artist's wife and his constant model; knowing their relationship as we do, their marriage, their years together, their separation and divorce, we want further to say the pictures document their relationship from its outset to its dissolution. Which I suppose they do, but to say only that would be to limit them, for they are, individually and as a group, more than merely personal. Like anyone's art, that is, the pictures may be autobiographical, but Diana is, at the beginning and at the end—and at times fiercely—as independent of the artist as she is from us and as we inevitably are from one another. In this she embodies the modern experience and is like us, and from this perspective we can be said to meet on equal terms, seeking to know one another. But the knowledge doesn't come easily, for she challenges rather than invites our encounters, and in those she can be initially defiant (*Diana #1 and #2*) PLATES 9 AND 12, guarded (*Diana #3*) PLATE 13, disbelieving (*Diana #5*) PLATE 15, passive (*Diana #6*) PLATE 16, skeptical (*Diana #7*) PLATE 17, resigned (*Diana # 9*) PLATE 18, or distanced (*Diana #10*) PLATE 19,—all daunting first impressions.

But never the whole story, for each image projects a complex of emotions and psychic energies—not surprising in view of the fact that each evolved over months of daily studio encounters between artist and model, husband and wife. Look at *Diana #4* (1981). Her presentation is formidable, as it is in all of the full length pictures, but she's at once more confident than challenging, more reserved than defiant; and she's also more relaxed, her gaze extending beyond us more than at us, her crossed arms modestly concealing her breasts more than indignantly encasing them, her overall control more natural than self-conscious. Because she is more generally rendered than her counterparts in the other paintings, and because she stands in a neutral space offering no distractions, she is in turn more abstract, more balanced and classical—think again of Piero—though she's no less sensuous for that, not anymore than

PLATE 11

DIANA #4 1980–1981

Oil on panel, 84 x 51

Collection of Hirshhorn Museum and Sculpture Garden, Smithsonian Institution, Thomas M. Evans, Jerome L. Greene, Joseph H. Hirshhorn, and Sydney and Frances Lewis Purchase Fund, 1985

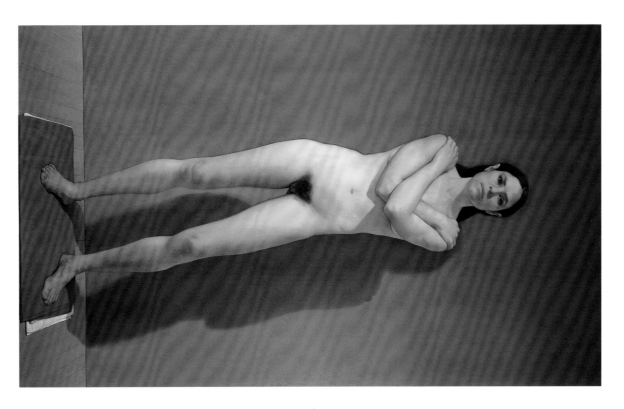

she's unresponsive emotionally. Look at the shadow she casts, its voluptuous contour and mysterious depth, and look, too, at the mats on which she stands, a robust and rusty orange, two flashes of white, a barely visible and fragile pink—layers of ordinary fabric transformed into extraordinary color, not to mention rich metaphors for feeling. Form and content here combine to produce an inspired image of regal dignity.

Diana #8 (1988) PLATE 10, is the smallest panel in the series—*Diana #4* is the largest—and offers our closest encounter with the model, focusing on just her head and upper shoulders, putting us face-to-face. It's a tense meeting. Diana looks inward as much as she looks at us; she seems at the end of her psychic and emotional tether, desperate, vulnerable. We naturally empathize—remember, this was the last of the paintings completed from direct observation—for, along with her pain, we recognize the strength and independence she's exhibited all along and, against the odds, here manages to retain. Look at the firm line defining her neck and shoulders and the set of her jaw, at the impenetrable depth of her eyes and her black hair, and, not least of all, at the delicate pink of the space she occupies and the way the brush caresses her head, creating an aura, like a halo. However hardened Diana's image here may be, it is at the same time tender, form and content joined to provide a poignant reminder of her problematic identity, which is in turn her humanity—and ours as well.

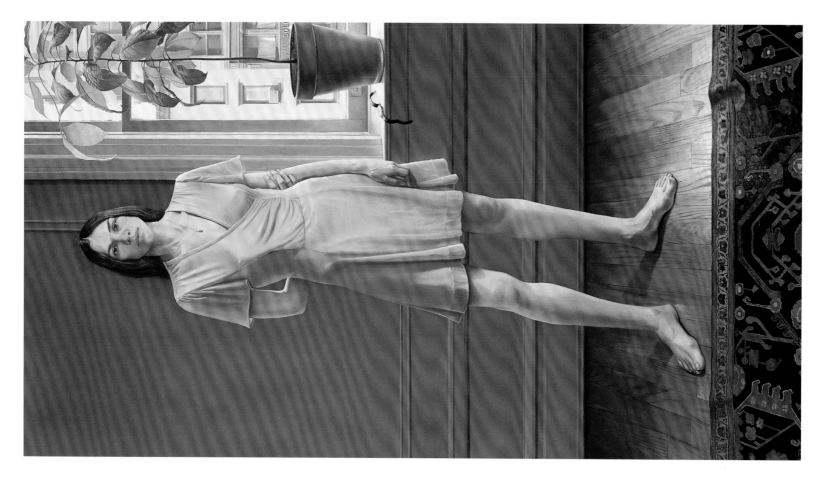

PLATE 12

DIANA #2 1973

Oil on panel, 84 x 48 in.
Private Collection

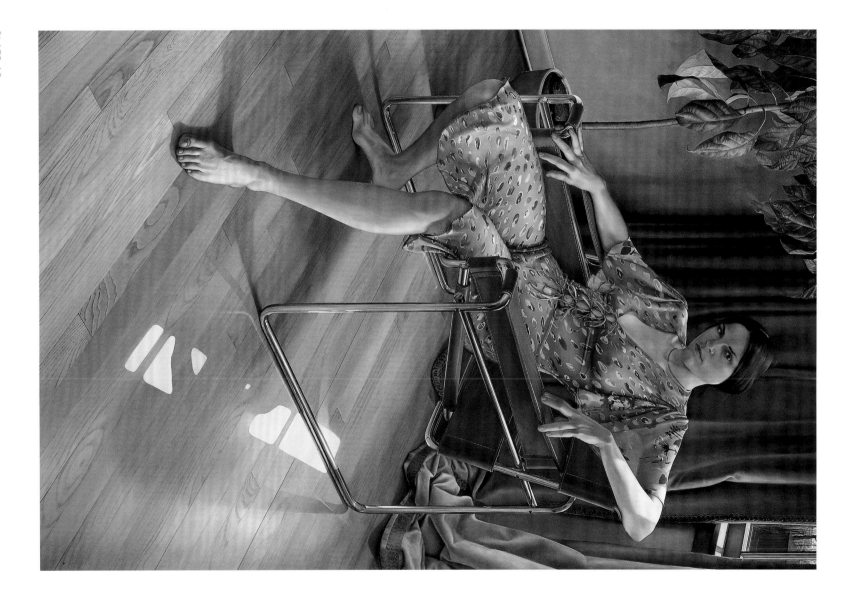

PLATE 13

DIANA #3 1976
Oil on panel, 72 x 50 in.
Private Collection

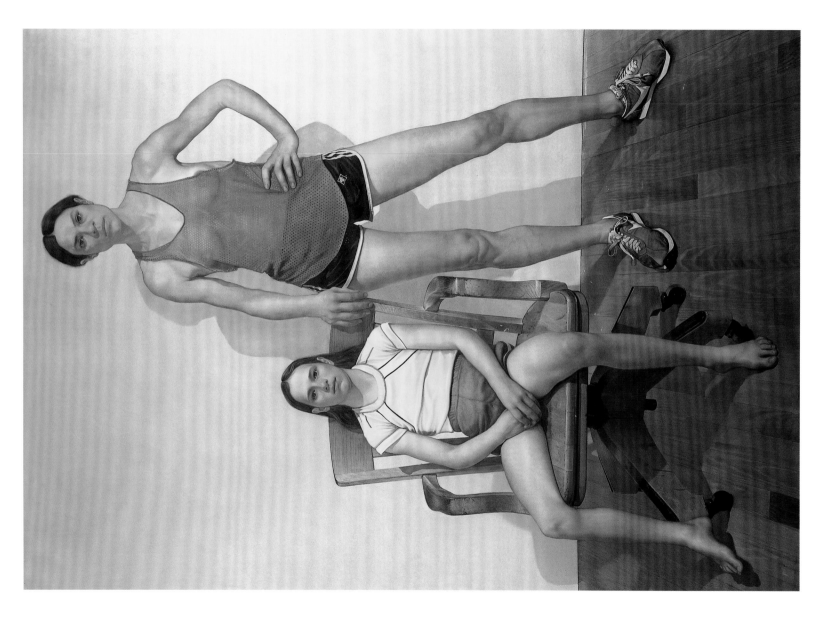

PLATE 14

DIANA AND DEIDRA 1978–1979

Oil on canvas, 84 x 60 in.

GUC Collection

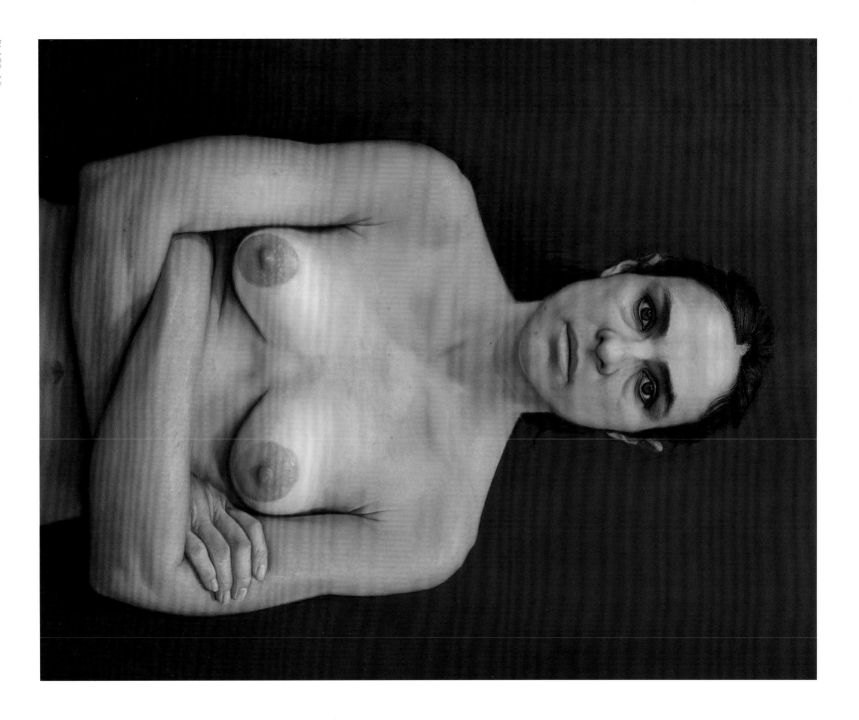

PLATE 15

DIANA #5 1984

Oil on panel, 32 1/2 x 26 in.

Collection of Dr. Gerard and Phyllis Seltzer

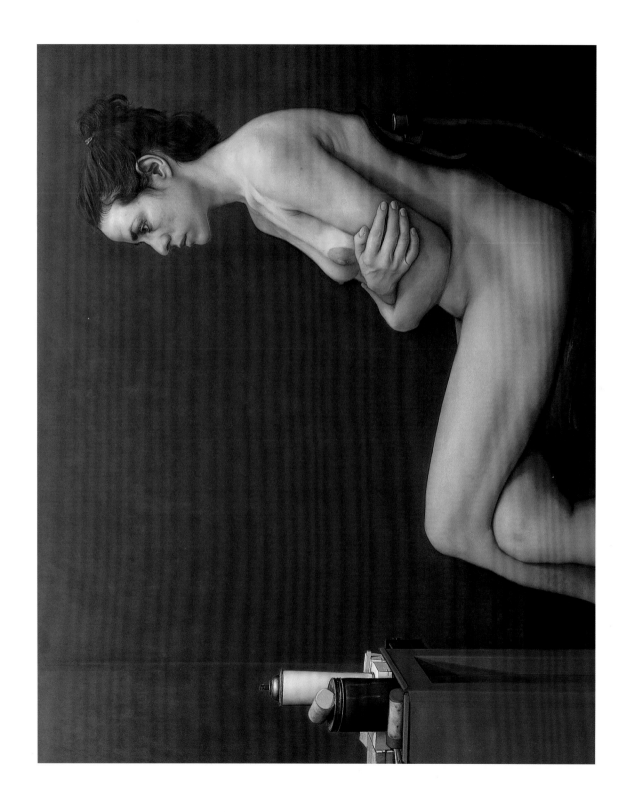

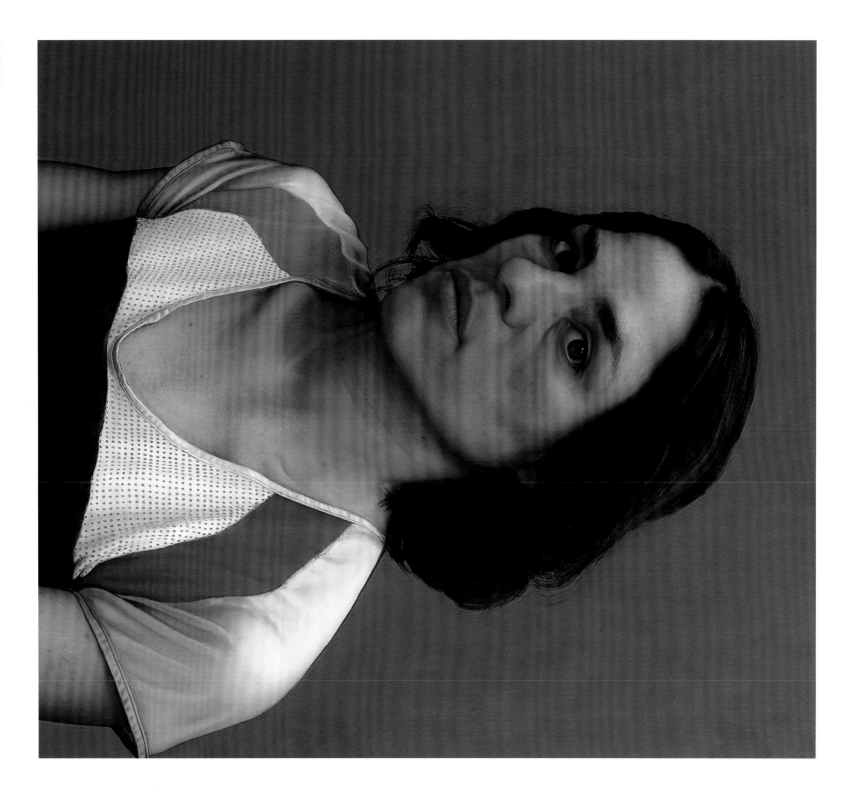

PLATE 17

DIANA #7 1985
Oil on panel, 22 3/4 x 20 3/8 in.
Private Collection

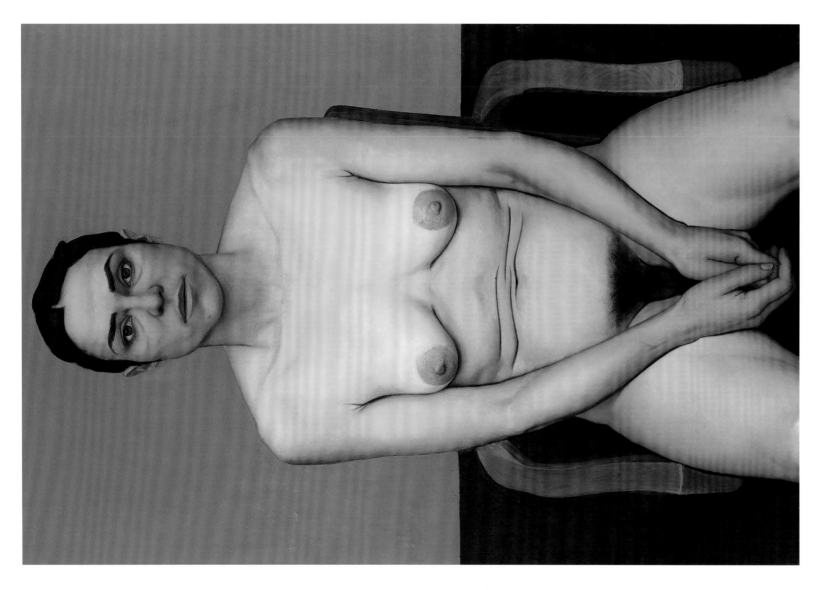

PLATE 18

DIANA #9 1990

Oil on panel, 56 x 38 1/2 in.

Collection of Stiebel, Ltd., New York

28

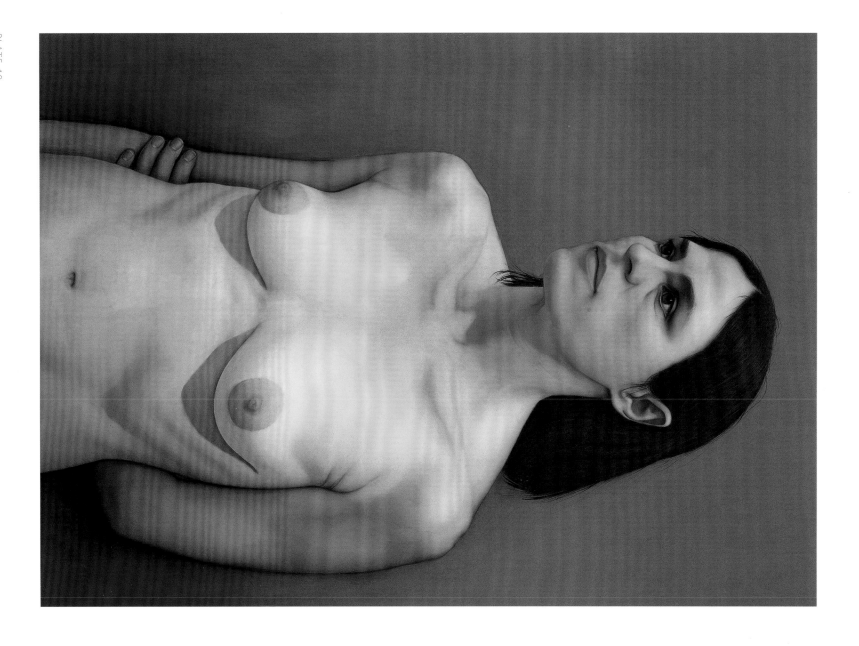

PLATE 19

DIANA #10 1988–1995
Oil on panel, 35 1/2 x 26 in.
Collection of Polly and Mark Addison

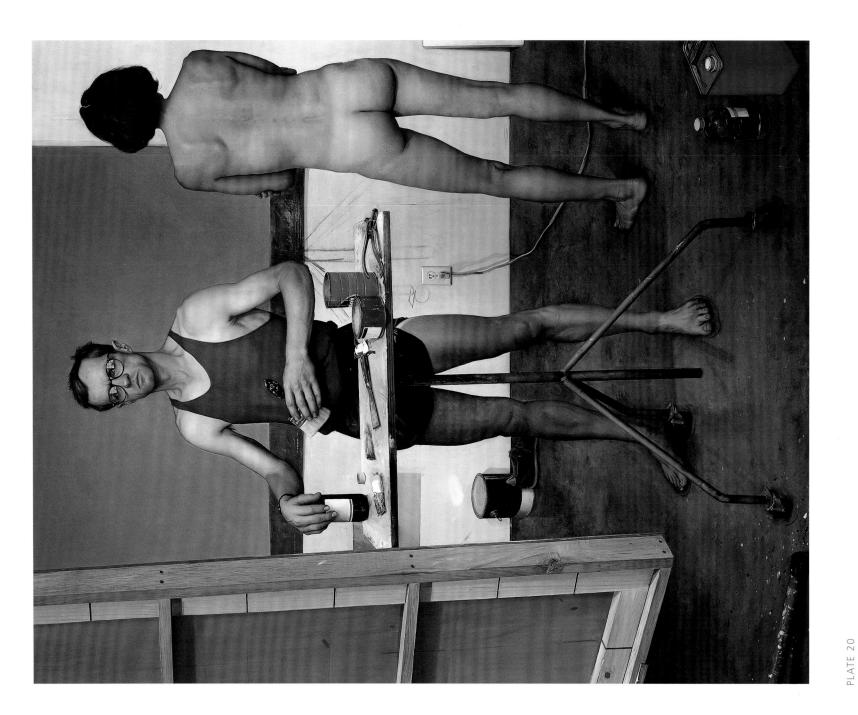

COUPLES

BECKMAN'S OEUVRE INCLUDES SIX PAINTINGS OF MALE/FEMALE COUPLES: *Double Nude* (1977–78) PLATE 2, *Studio* (1985–86) PLATE 20, *Man and Woman* (1986–87) PLATE 21, *Woman and Man* (1987–88) PLATE 22, *White Painting* (1990–99) PLATE 26, and *Overcoats: American Modern* (1998–99) PLATE 30. The first four image the artist and his wife, and in each one he meets, and challenges us with his gaze—as Diana does in the majority of the paintings of her—while she in one way or another avoids making eye contact. Only in the pictures of the 1990s do artist and model both address us. With all six pictures, then, we are invited into the couples' world, but here the issue isn't so much *our* relationship with the figures—which it is in the Diana series—as it is *their* relationship with one another. So each picture is about control, for that's what relationships are all about.

The male/female relationship is least problematic in *Double Nude* where the vision is youthful and romantic, Edenic in its specific compositional echo of Albrecht Durer's (1471–1528) *Adam and Eve* (1504) and graphic in its stylistic recollection of the Northern Renaissance masters generally. Discordant notes nonetheless temper the relationship and project its otherworldly appearance into the here and now. The figures are tense, their expressions separately questioning us as if we had intruded on them. His look stops us, but she looks past us, as if at someone over our right shoulder, provoking a shared anxiety. That the encounter is confrontational is evident in the couple's clasped hands, an awkward, claw-like tangle of lines indicating less that they are willingly joined than that he has impulsively grabbed her in response to the threat we pose. An undercurrent in their relationship is here revealed: male and female seem equal, but he assumes a dominant role when they meet us as a couple. His challenge is forthright, his attention fixed; she, at the same time, yields reluctantly and is more reserved—her identity, like the object of her concern, is less specified and accessible. In the moment these partners meet the world they become separate individuals, and their paradise becomes conditional.

Studio is one of the most ambitious of all Beckman's pictures—arguably a masterpiece in that it summarizes the artistic concerns that occupied him from the late 1960s to the mid-1980s, including the human figure, landscape, still life, and allusions to the history of art. Its obvious source is Diego Velasquez's (1599–1660) *Maids of Honor* (1656) the artist facing in mirror image a situation we experience as a direct encounter. The Spanish master's *Rokeby Venus* (1644–48) is also recalled in the nude female

figure seen from the back. The painting is willfully self-indulgent, the creator athletically powerful in running shorts and shirt, standing in the center of his universe, surrounded by his paints, his brushes, his model, his study for landscape painting—everything confirming his identity, his dominance of the space blatantly declared by the phallic vertical pipe splitting his legs and supporting his palette. His masculine authority is so powerfully asserted it threatens to eclipse his model, who is naked and turned away, as if awaiting his direction—another object he controls. For all the information we are given about him, we are given none about her. But there is irony here, for though he faces us, he is also barricaded by the very tools and work stand he employs and by the complex planes and angles describing them; she by comparison, is fully accessible, with no object between her and us. Averted, her body alone speaks—her shoulders firm, her stance confident, her razor-sharp contours vital, her dark hair mysterious. As a couple, back-to-back, male and female seem alienated, distanced from one another, each privately absorbed, each there to do a job in the studio where he alone makes the rules—and bears responsibility for them. Which can make it a lonely place in spite of all it contains, all of his objects in the end affecting comfort no more than his model affects communion. Turned away from him, she assumes power by fixing his solitude; even her nakedness underscores his isolation. But his inspiration—indeed, the reason for the painting itself—lies palpably between them.

The last two paintings in which Diana appears are forbiddingly austere and unsettling, the figures presented in studious retreat from one another and openly resistant to personal exchange of any kind. Each seems determined to assert an individual identity, so control is more at stake than ever before. In *Man and Woman* PLATE 21, he stares out at us, his face tense, his body taut, its contours abrupt and angular; his image is assertive but neither assured nor confident. A vertical line extends from an airless background panel through his left arm and leg, isolating him in a cell-like space. She is isolated in a cell of her own, her head tilted back, her expression distant and self-absorbed. The pants he wears conceal his body, but his anxiety is laid bare; her body is fully displayed, but she is cloaked in inaccessible reverie. Both male and female aggressively seek control here—one actively, one passively—but they speak past one another.

Woman and Man reorders the terms of the couple's relationship, as she stands on the left, he on the right. Her gaze remains resolutely elsewhere, but her statuesque body is frontal and in every way secure and authoritative. He, by comparison, is the more passive of the two; we meet him eye-to-eye, but he turns slightly from us, the first time he has done so. In addition, he adopts a pose identical to hers, as though she has declared her position, and he, however reluctantly—for he still wears those pants—

has stepped aside to acknowledge it. If, as a couple, they were conceived in Eden, they have come of age in the modern world.

White Painting PLATE 26 and *Overcoats* PLATE 30 return the male to the left side of the picture but otherwise present their couples on a level playing field—both figures fully frontal and equally close to us, both making eye contact with us, both either entirely naked or fully clothed—mutually in control. But the worlds the couples occupy differ radically, one an abstract field of pigment, the other a rural vista, the first time we've seen one of the couples in a natural setting. As its title suggests, the color in *White Painting* carries significant expressive weight in the picture. Deeply saturated through-out, it feels as substantial and volumetric as the figures themselves, as if equally shaping and being shaped by them. But the selection of white to do that job did not come easily. On three occasions prior to becoming *White Painting*, the picture was considered complete, left the studio for exhibition, and then returned: first as *Red Painting* PLATE 23, then as *Gray Painting* PLATE 24, and a third time as *Yellow Painting*—thus, as its dates indicate, its exceptionally long gestation. In each version the dominant color was conceived, it seems to me, less as a background for the figures than as an environment actively connecting them and as a visual metaphor for the character of their relationship, which, in formal terms, is evenly and everywhere shared. Yet it equally resonates with feeling, alternately warm and cool from one version to the next. Looking at *White Painting*, we may want to say the relationship is finally cold, for white can be icy, though we may also want to say it is pure, for white can also be the color of light, life-giving light containing all colors. You decide. Just don't overlook the fact that color here is more than decorative—in structuring the couple's world, it is political.

Overcoats: American Modern—the title conflates Nikolai Gogol's (1809–1852) famous short story and Grant Wood's (1892–1942) equally famous painting—required as much time to resolve as *White Painting*, close to a decade. In it, landscape unites the couple and measures their equality, they are mutually at ease in its embrace. A cluster of buildings dominated by a grain elevator lies in the distance, a big sky and fair weather clouds crown the figures, and an open road sweeps behind them, perhaps a reference to motorcycling, a passion the artist shares with his model here, Jeannie Zetterstrand. You might say the rural landscape in this picture functions like the color field in *White Painting*, meaning it's political, and I'd be inclined to agree. Beckman himself has told me that for him the paintings together define who he is as a painter—his need, for instance, to get the right model for each pictorial idea, for each is like a collaboration, and, too, his tenacity in staying with an image until he "gets it right."

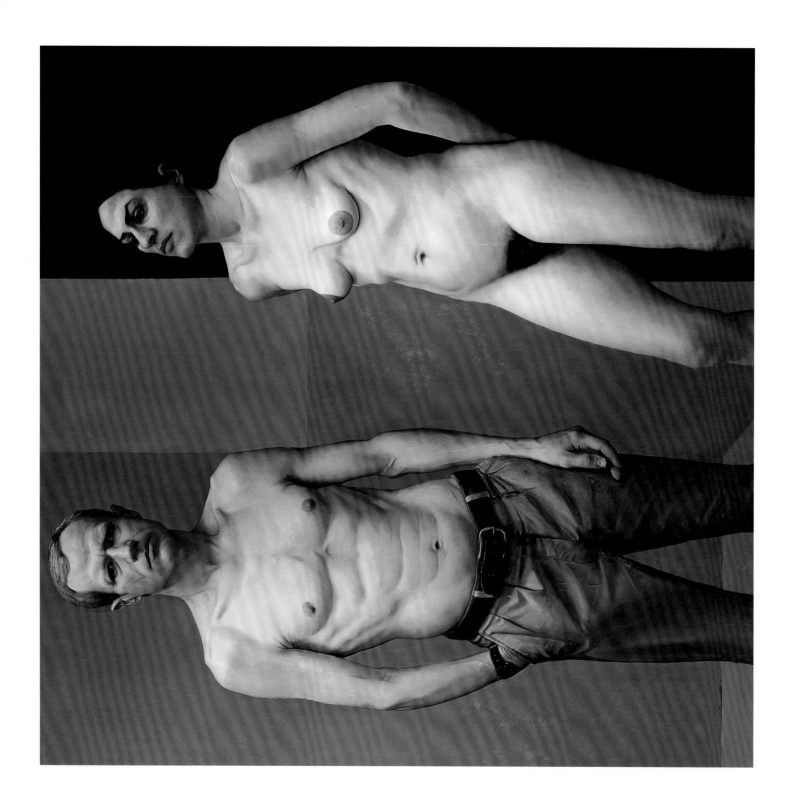

PLATE 21

MAN AND WOMAN 1986–1987

Oil on panel, 79 x 79 in.

Collection of Philip and Leticia Messinger

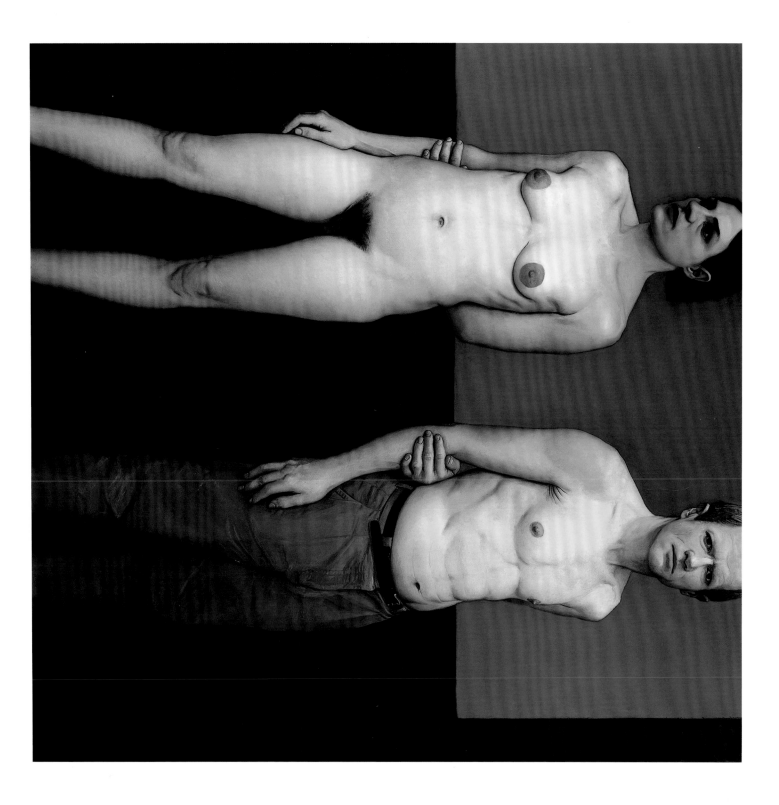

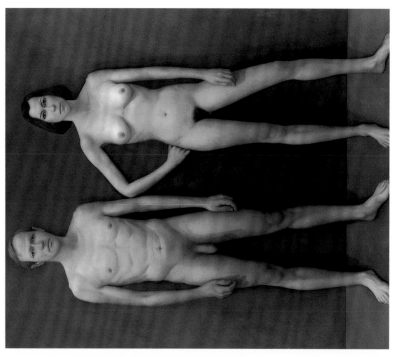

GRAY PAINTING (COUPLE) 1990–1999

Oil on panel, 90 x 80 in.

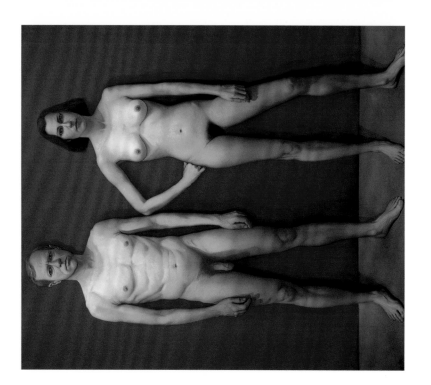

RED PAINTING (COUPLE) 1990–1999

Oil on panel, 90 x 80 in.

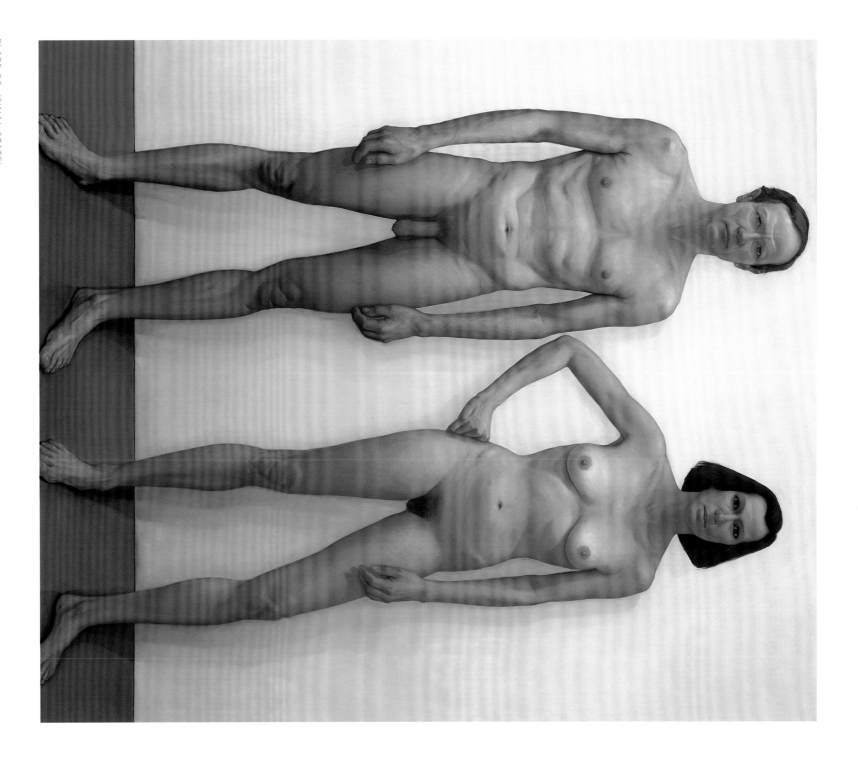

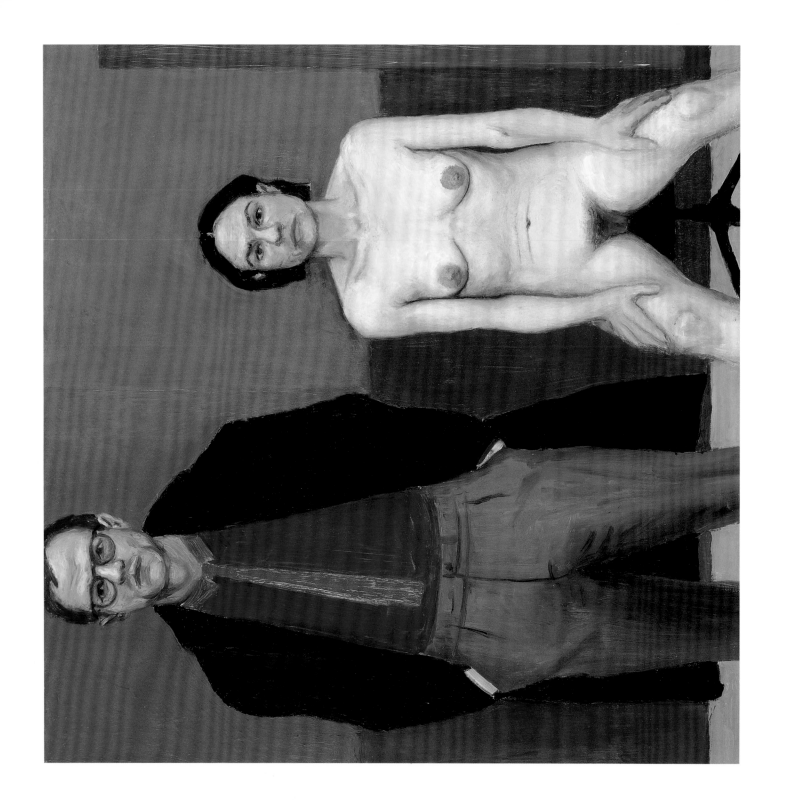

PLATE 27

OVERCOATS STUDY #1 1988

Oil on panel, 16 x 16 in.
Collection of Rick and Monica Segal

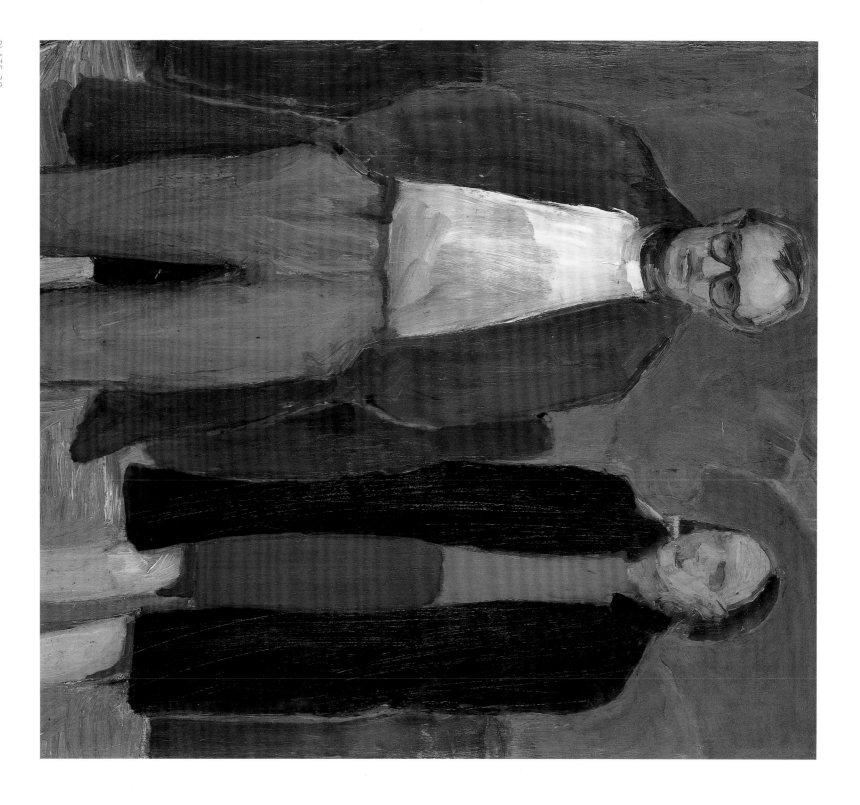

PLATE 28

OVERCOATS STUDY #2 1989

Oil on panel, 15 x 13 in.
Private Collection

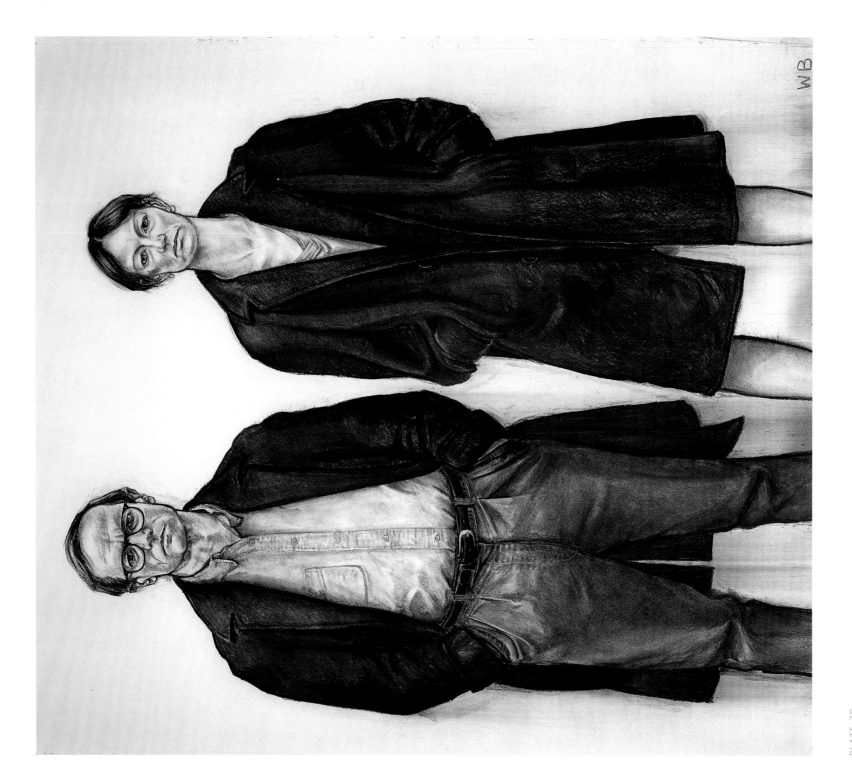

PLATE 29

OVERCOATS #1 1997

Charcoal on paper, 90 x 76 1/4 in.

Collection of Thomas J. Huerter

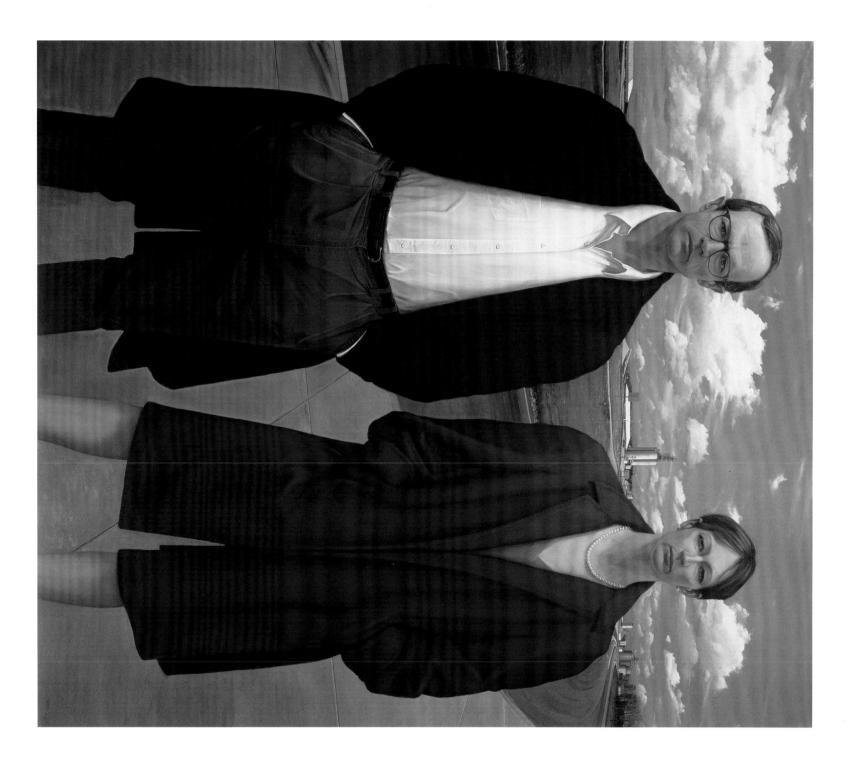

PLATE 30

OVERCOATS (AMERICAN MODERN) 1998–1999

Oil on panel, 90 x 78 in.

Collection of Seven Bridges Foundation

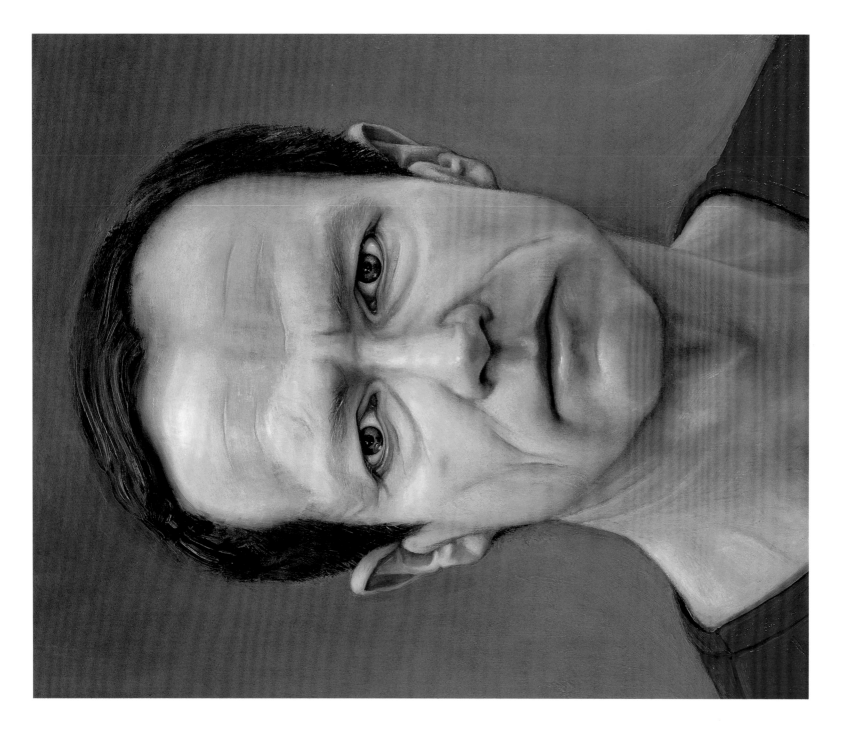

SELF PORTRAITS

BECKMAN HAS TALKED ABOUT HIS ENTERPRISE AS BEING A LONE EFFORT, containing himself on the one hand, expressing his emotions on the other. In his self portraits those emotions seem generally under control—not so close to the surface, as if he's here immune to the troubled determination he exhibits in the later couples with Diana. We can understand how that might be the case. I remarked earlier that the studio can be a lonely place, yet the self portraits encourage me to think it could also be a place offering welcome solitude, a site free from the demands of responding to another person—whether spouse, partner, or friend—and having to sort out the dynamics that necessarily attend such relationships. Not that looking at yourself in the mirror all day long is an altogether comforting idea—even the most dedicated narcissism must have its limits—but the opportunity to contemplate and image yourself in the absence of any other self is nonetheless appealing. Beckman has told me that when he presents slide-talks on his work he's regularly asked why he paints so many self portraits. One of his answers is pretty obvious, namely, that he alone is the model whose availability he can always count on, which we can fully appreciate in light of the way he goes about his job. A second is that he responds to the challenge of regularly measuring himself, meaning not what he looks like, for a series of photographs could do that, but measuring how he thinks and feels about himself—in other words, what his relationship to his self consists of at any particular point in time. And the final answer, more cautiously tendered, is that his self portraits will hopefully lodge his image among the paintings he so highly esteems in art's history—as though, because they are by definition forged independently of other subjects, they provide his one exclusively self-determined shot at immortality. We would be right in saying a strong ego operates in this response, but we would miss its point if we failed to grasp the enormous burden of responsibility that informs it. So, the studio again becomes lonely, but Beckman seems content to live with that.

The self portraits are generally smaller in size than Beckman's other figurative paintings, but they are nonetheless large in scale, his image front and center, filling the space—as close to us as I imagine him to have been to both the mirror he looked at and the

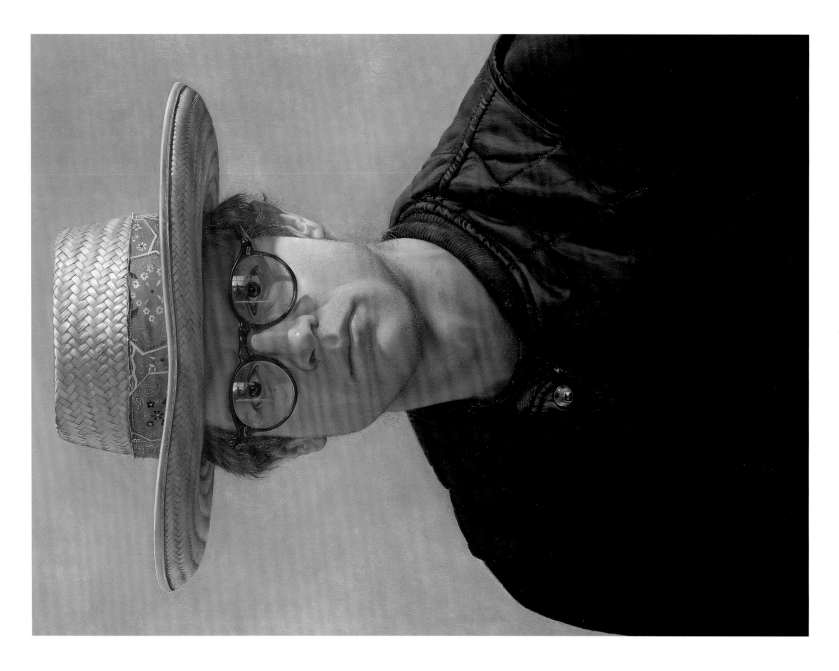

PLATE 32

SELF PORTRAIT WITH HAT 1979–1980

Oil on panel, 21 1/8 x 16 3/4 in.

Private Collection

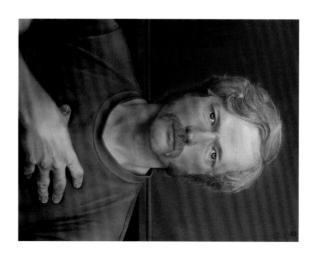

panel he worked on—thus, formally in control. And confident—enough to adopt Albrecht Durer's (1471–1528) hand-on-chest pose, to challenge Hans Holbein's (1465–1524) painting of blond hair, to dare us, in the manner of Jan van Eyck (about 1395–1441) to read all the miniature spaces reflected in the glasses he wears; even to don Vincent van Gogh's (1853–1890) straw hat. The art historical references, some more overt than others, are all contained in pictures from the 1970s, and they obviously signal a youthful confidence—nowhere more secure or appealing than in the breathtaking *Self Portrait With Hat* PLATE 32—wherein every ambition, whether of form or content, is attainable. It was a heady decade for realist-type painting, which enjoyed a renewed ascendancy at the time, and Beckman, ever competitive,—he regularly pushed friends like Gregory Gillespie as much as he was pushed by them—showed that he was as masterful as anyone around. But that same confidence persists and deepens in the self portraits of the past two decades, their full maturity evident in the faces' probing and resolute gravity—as much as he looks out, he looks inward—and the pictures' broader, more simplified and abstract rendering, which steadily eschews technical dazzle and *trompe l'oeil* effect. Raising the stakes again and again, they increasingly focus on the artist's relentless encounter with himself, nothing more—and decidedly nothing less—in each case reminding us that his self is finally his sole anchor, as it necessarily is with each of us in modern experience.

The simplification and abstraction I cite in connection with Beckman's self portraits are, as I've already suggested, evident in his images of Diana and his couples as well—recall the coats in *Overcoats*, they're more like color masses than scrutinized and identifiable fabrics—reflecting a tendency we often see as artists mature and their vision evolves from the particular to the general. In the best cases, it seems a natural process of embracing more of the world and developing deeper insights into its work-ings. Which it is in Beckman's case, and we are moved when we see it, for it reinforces private hopes for our own attempts at understanding—we may even feel it's what art is all about. For an artist, however, the process can also have a practical side having to do with time. Beckman, for instance, has remarked that he's come to painting more broadly because he increasingly feels he has more to say and less time to say it and that spending a year on a painting is becoming a luxury he worries he can't afford. He's also said he's become more impulsive in the studio than in his life outside it, less patient about rendering minute details, more eager to get on with more pictures. Approaching sixty, he's certainly not old, not by today's standards, but his thinking about aging is as natural a process as the loosening of his brush. In looking at his self portraits, we should think about both, for only then do we grasp their combination of the particular and the general—and the fullness of his and their humanity.

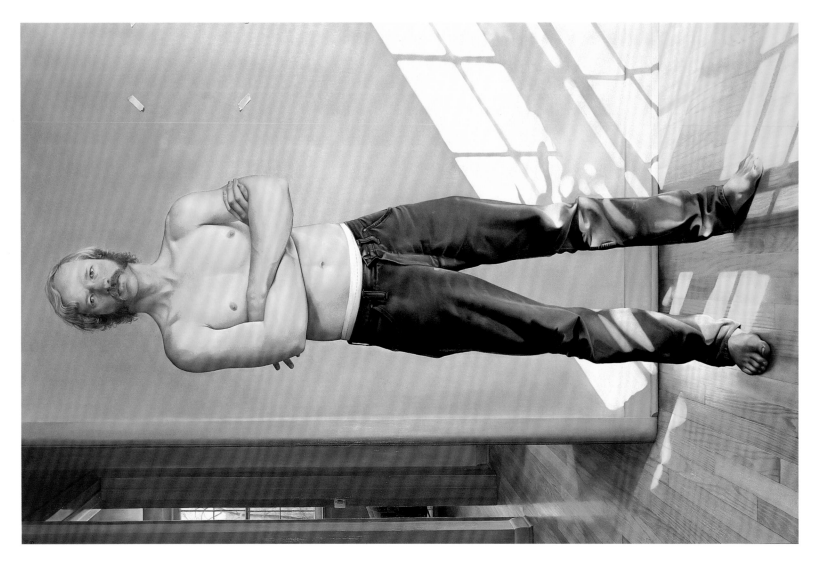

PLATE 34

SELF PORTRAIT 1974

Oil on panel, 72 x 48 in.

Collection of Edmund Pillsbury

PLATE 35

SELF PORTRAIT 1976

Oil on panel, 11 3/4 x 9 3/4 in.

Private Collection

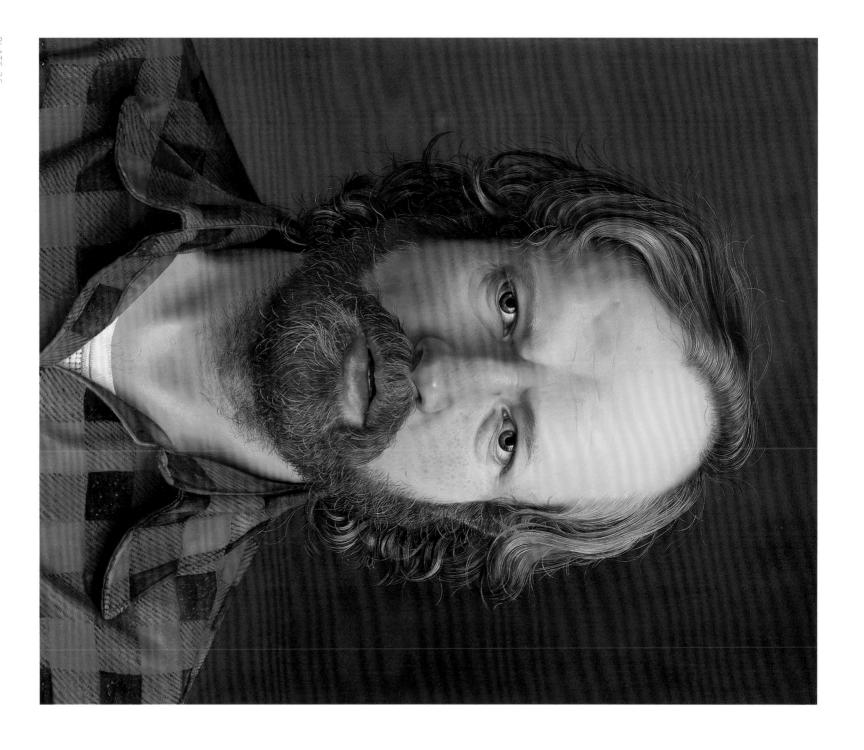

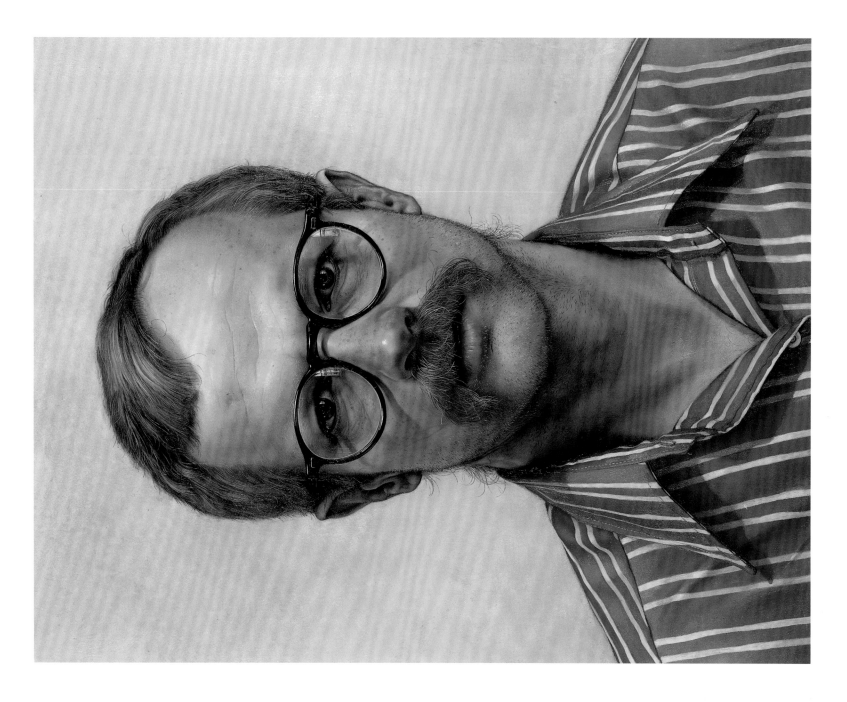

PLATE 36

SELF PORTRAIT 1978

Oil on panel, 16 1/4 x 13 3/8 in.

Private Collection

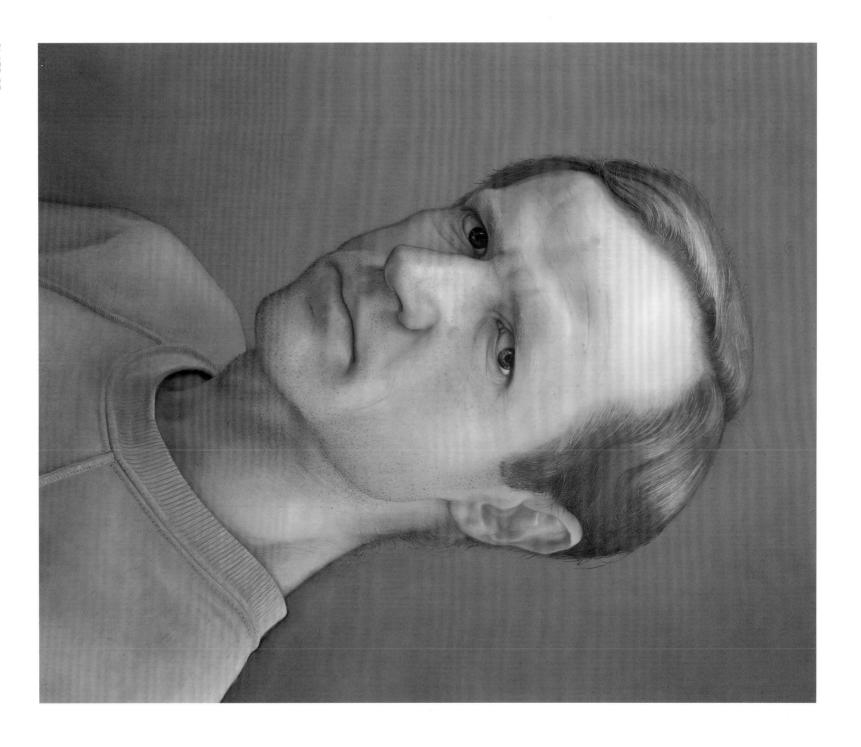

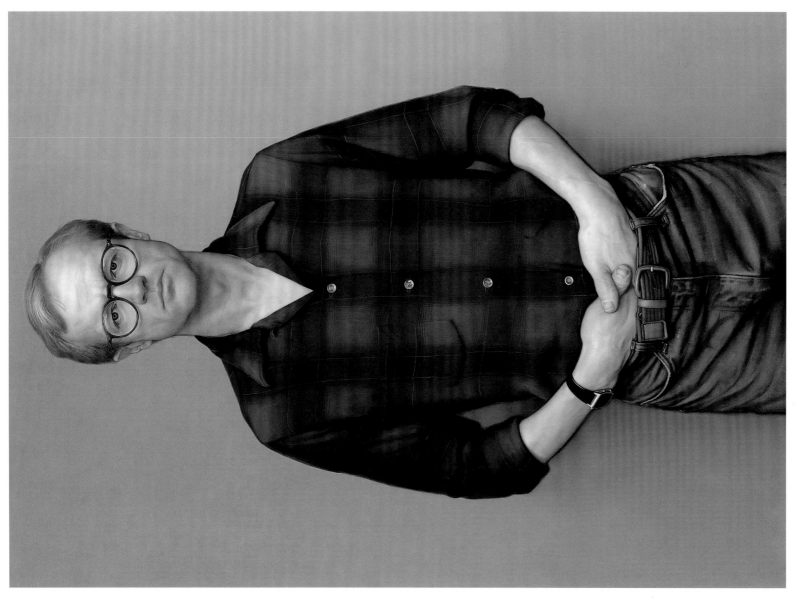

PLATE 38

SELF PORTRAIT 1982

Oil on panel, 50 x 36 1/2 in.

Courtesy of Yale University Art Gallery

Lent by Richard Brown Baker

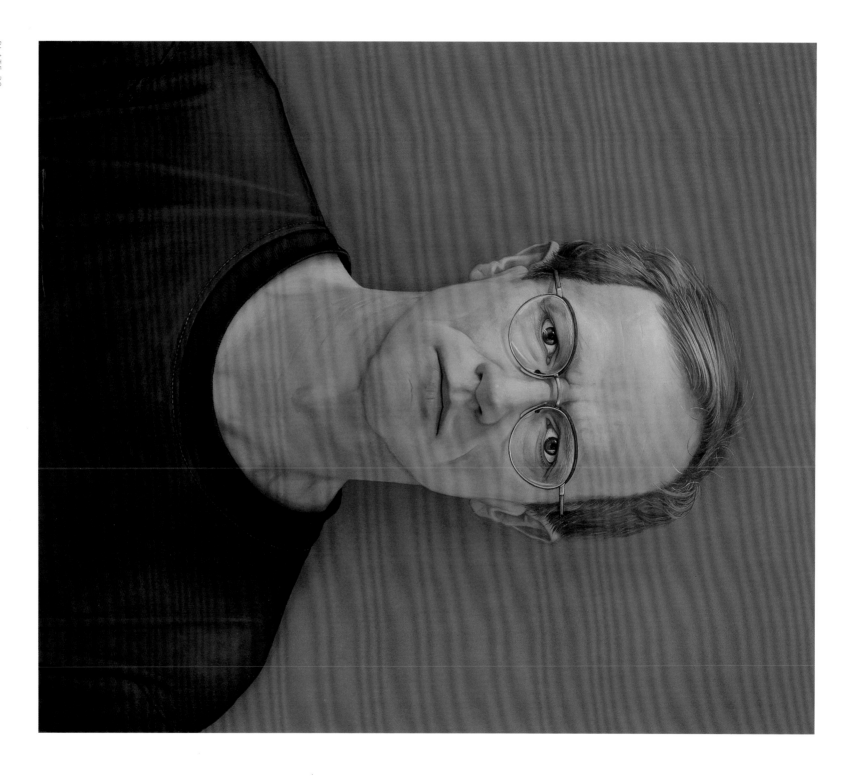

PLATE 39

SELF PORTRAIT WITH BLUE SHIRT 1997

Oil on panel, 24 x 20 in.
Collection of Myrna and Norman Katz

51

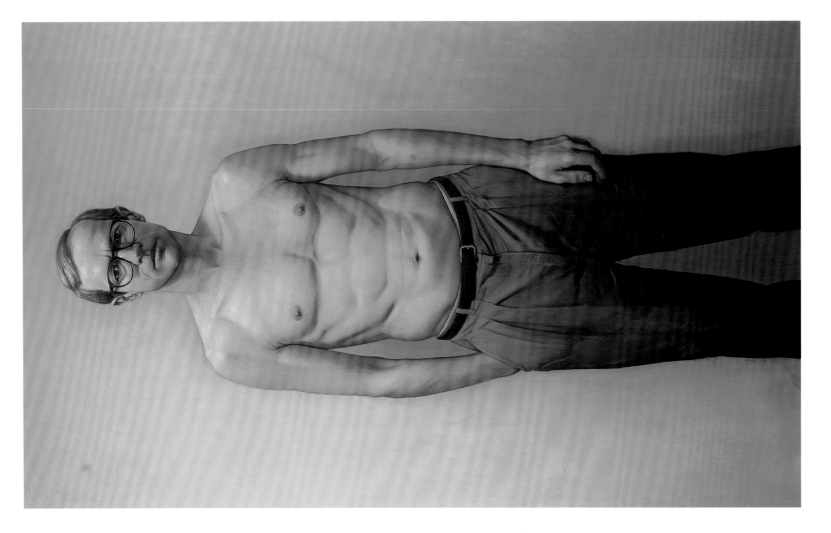

PLATE 40

SELF PORTRAIT (WITH GREY PANTS) 1993

Oil on panel, 80 x 50 in.

Sydney and Walda Besthoff Collection

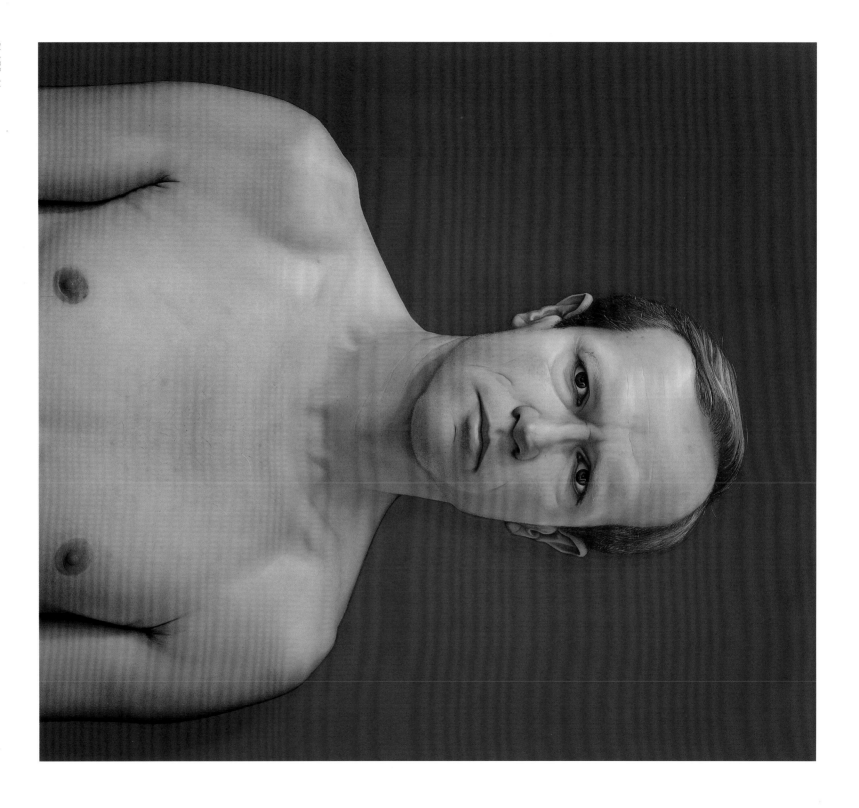

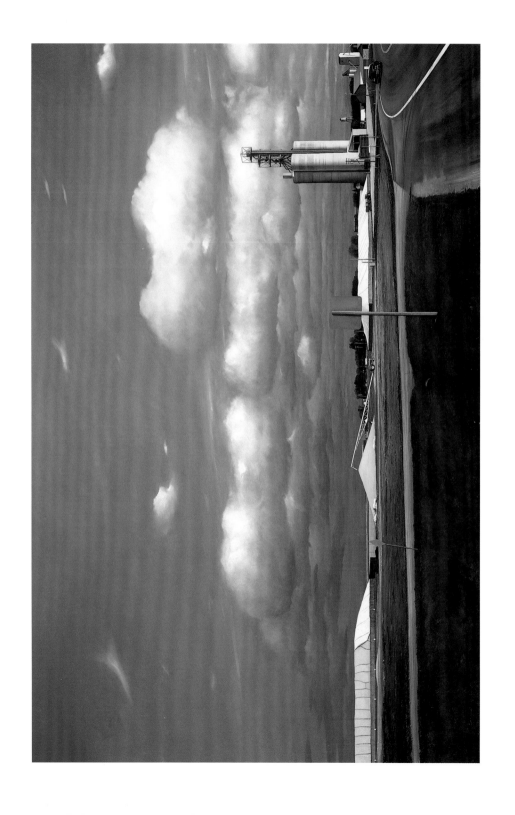

PLATE 42

C.C. ELEVATORS 1996

Oil on panel, 64 x 98 1/2 in.

Collection of Seven Bridges Foundation

LANDSCAPES

BECKMAN'S INTEREST IN LANDSCAPE PAINTING DATES FROM 1970, THOUGH IT became an ongoing concern in his art only about a decade later. The interest is natural insofar as he was raised on a working farm, and it partially accounts for the decision to move from Manhattan to Dutchess County, New York, in 1974. "The landscapes started when we went to my parents' farm in Minnesota. We went in part for a vacation, but partly because I wanted to do some landscapes. I had never done any—I mean not directly from nature—so I just got on my father's tractor and drove out in the fields and painted what was right in front of me. At first, I wasn't trying to do anything with the pictures—I wasn't trying to find a specific site or make a statement, I just wanted to paint." But he wanted to open and expand his art as well. "I felt the color in my figure paintings needed to be lifted, and the landscapes also got me to see things that were more than eight feet away, which is where my models were posing. I had to work on something that was half a mile or a mile away, and I really liked that."

The move to Dutchess County focused his interest on particular landscape subjects. "I wanted a place with working farms that still functioned, that had cattle, silos, and machinery, that were still exploiting the land, so to speak—not farms you'd visit on Thanksgiving to see your grandmother. I also wanted that hassle between the environmentalist and the farmer. It doesn't surface very often in the eastern press, but you get it endlessly in the mid-west—the chemical fertilizers they put on the ground, the way they push down every tree or use a bulldozer to straighten out a stream that meanders through a field, the way they run a power line directly through otherwise productive land if they want electricity. And I fell in love with the big Harvester silos that are all over the area. They're a deep blue-black color, they're very tall, they have an ominous feeling, they resemble missiles; and yet, what do they do? They store food. they're the breadbasket of our livelihood. I liked that irony. I wanted that feeling of an altercation with the land."

Working farms, subjects spreading a mile or more from view, an underlying quarrel between man and nature, plowing the soil to renew life, storing the yield, Beckman

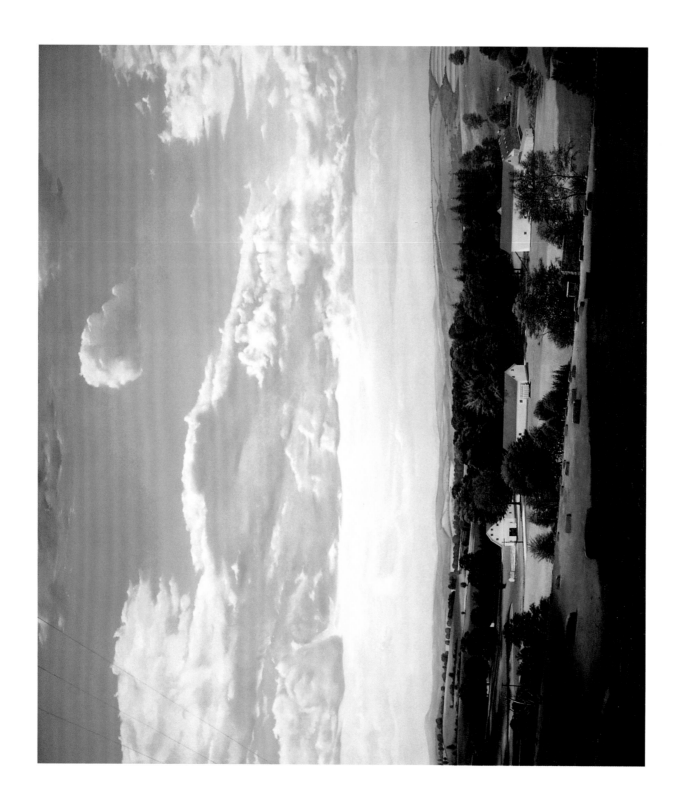

PLATE 43

PARSHALL'S BARNS 1977

Oil on canvas, 63 x 72 in.

Collection of Malcolm Holzman, New York

56

initially selected his panoramas while running the rolling country roads near his home, but over the years the fields of his Minnesota youth have equally attracted him. He generally makes drawings and sketches on the site and then employs memory to realize in the studio the final image, which, like many of his figure paintings, evolves over many months. Oil on canvas, not panel, is generally the medium of choice with the landscapes, partly because canvas textures the paint, lending it an earthy feel, but its use also suggests the artist pretty clearly envisions his subject from the outset and is confident he can realize the image without constant sanding and repainting that could erode the support. Examples from the early 1980s, however, are executed in pastel on paper, a medium he adopted when a tree-spraying accident injured his painting hand and forced him to draw with a looser grip than he normally employed; pastel accommodated his physical need and at the same time provided more of the heightened color he was looking for in his pictures.

Like the figure paintings, too, the landscapes are frontal and accessible—a road, a fence, a furrow, or a string of electrical poles and wires greeting us at the picture's edge and allowing us to ease into and across the patiently described terrain. Accustomed to high-speed freeways and anonymous interstates, we find in these images a slower pace and a land that has retained its character in spite of human intrusion. So we pause regularly to absorb details of place and season, letting them accumulate, digest-ing them, feeling in the face of them—in the face of their spreading inclusiveness—the fullness of nature's scale and the slow rhythm of its operations. People appear to live comfortably enough in these places, and certain passages hint at a pastoral accommodation of tractors, barns, silos, and elevators, the mid-west equivalent of the cathedral towers you first see when approaching outlying towns throughout France or Germany—places where communities gather. But nature is ultimately the larger force, its mood sounding the dominant chord above any particular site, its scope easily embracing man's efforts to alter the horizon. That this is the case is nowhere more apparent than in Beckman's skies, which characteristically cover over half the surface of any given picture—and can stand the test of any John Constable (1776-1837). They are invariably active, their wide range encompassing the tension of an approaching storm and the release of a passing front, the dust of summer heat and the clarity of autumnal cool, the weight of hibernal gray and the promise of vernal blue. They measure what goes on beneath them, and they shape its meaning, not unlike the abstract color fields in the later figure paintings. In enabling the artist to broaden his palette, they equally provided a vast arena for the expression of his feelings. They are carefully observed and carefully rendered, qualities that inform everywhere their passion and intensity, and we stand in awe before them.

57

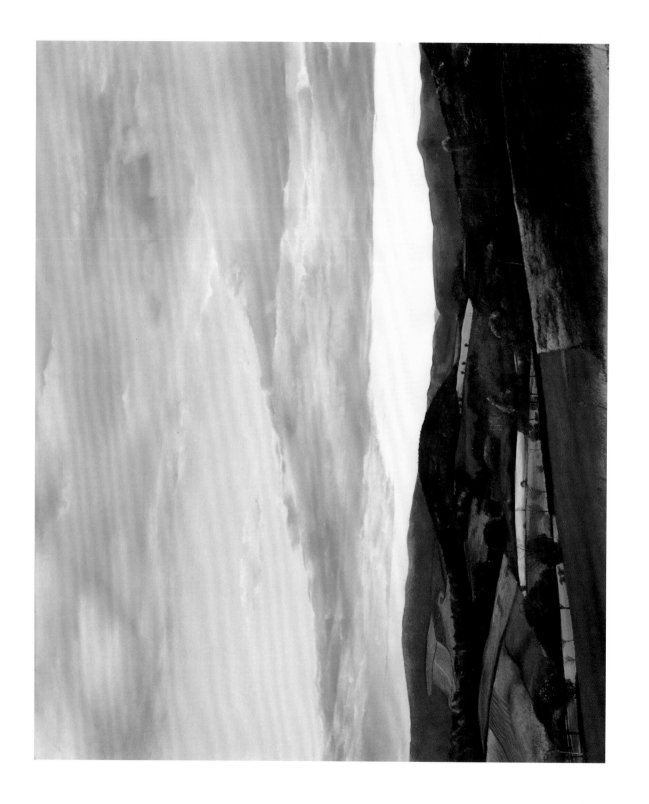

PLATE 44

WEBTUCK HILL #2 1974

Pastel on paper, 19 1/4 x 23 1/4 in.

Collection of the Art Institute of Chicago

Gift of Jalene and Richard Davidson

PLATE 45

HAWK CREEK, MINNESOTA 1979–1980

Pastel on paper, 23 x 40 in.

Private Collection

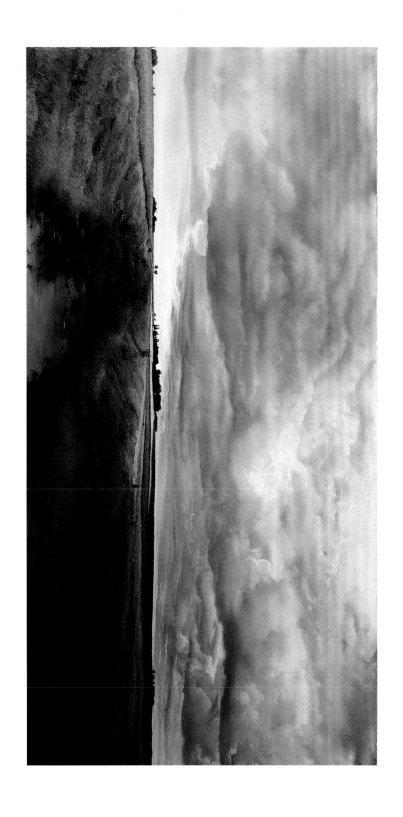

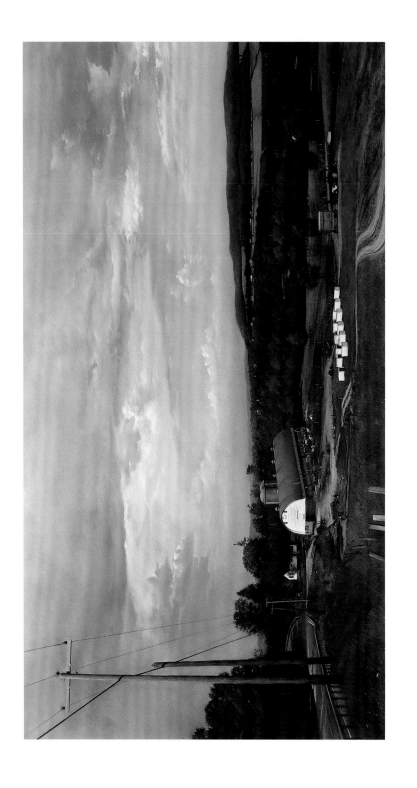

PLATE 46

DELAVERN HILL (MURPHY'S FARM) 1981

Pastel on paper, 33 1/4 x 57 1/4 in.

Collection of Uffleman/Technimetrics

PLATE 47

THE VAN LEA FARM 1981
Pastel on paper, 34 1/4 x 60 1/8 in.
Collection of David and Geraldine Pincus

PLATE 48

THE BALDWIN FARM 1982

Pastel on paper, 40 3/8 x 74 1/2 in.

Collection of Northern Trust, Chicago

PLATE 49

HILLARIE FARM 1982
Pastel on paper, 34 1/8 x 60 in.
Collection of Brown and Wood LLP

PLATE 50

KAYES FARM, LATE SUMMER 1982

Pastel on paper, 25 1/2 x 54 in.

Des Moines Art Center Permanent Collections

Dwight Kirsch Bequest Fund in memory of his son, John

Photography: Ray Andrews, Des Moines

PLATE 51

MAYNARD, MINNESOTA 1982

Pastel on paper, 34 1/4 x 60 in.

Collection of the Art Institute of Chicago

Gift of Anne Searle Meers (Bent) and Mr. and Mrs. Daniel C. Searle

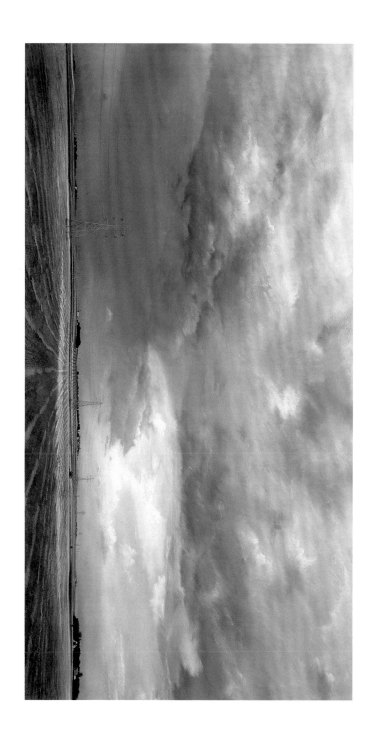

Photography: Courtesy of the Art Institute of Chicago

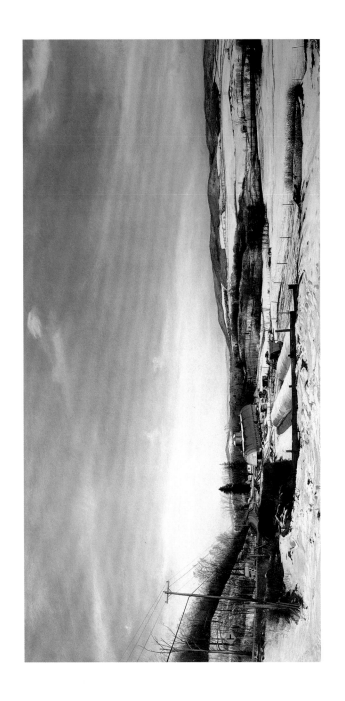

PLATE 52

DELAVERN FARM, WINTER: LOADING SILAGE 1983

Pastel on paper, 48 1/4 x 80 1/2 in.

Collection of New Britain Museum of American Art, Connecticut

Special Projects Fund

PLATE 53

H.G. PAGE LUMBER YARD 1983

Pastel on paper, 25 x 57 in.

Collection of Malcolm Holzman, New York

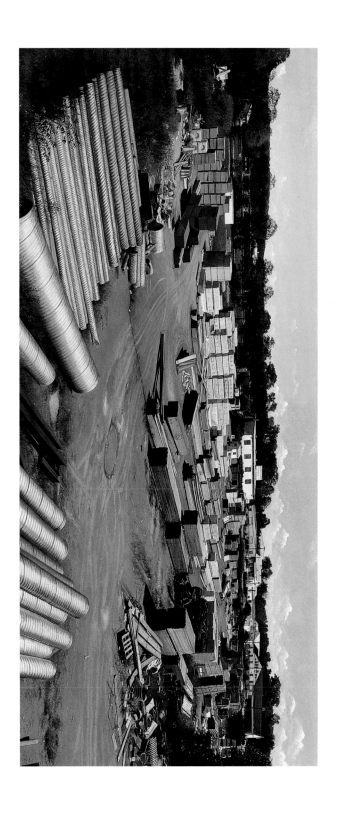

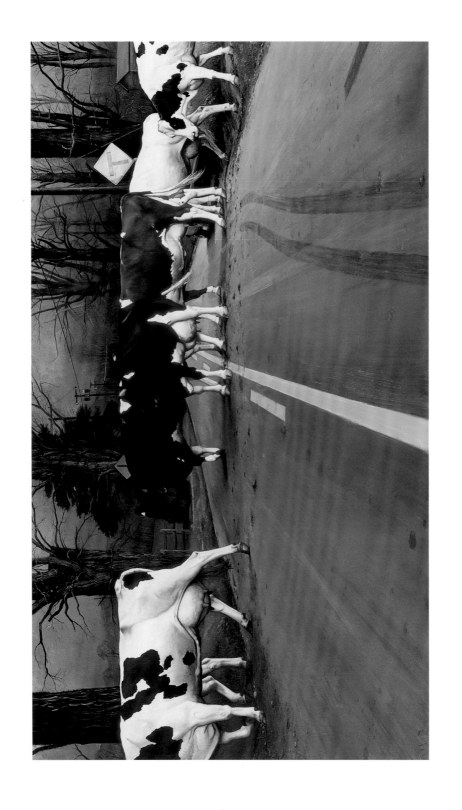

PLATE 54

CROSSING 1983–1985

Oil on canvas, 90 x 156 in.
Collection of Martin Z. Margulies

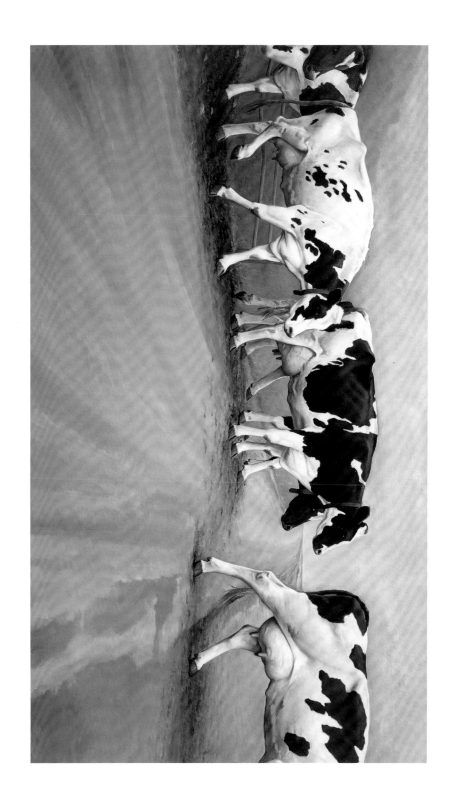

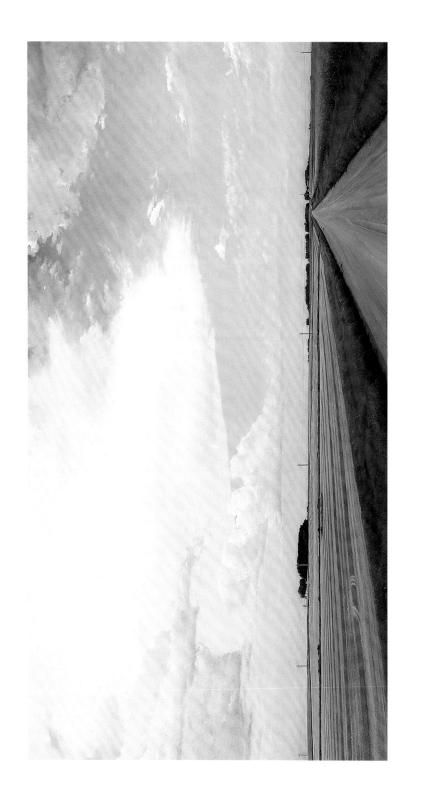

PLATE 56

GRAVEL ROAD 1983–1984

Oil on canvas, 76 x 144 in.
Private Collection

PLATE 57

NEW MILK BARN 1983–1984

Oil on aluminum board, 48 1/4 x 84 1/4 in.

GUC Collection

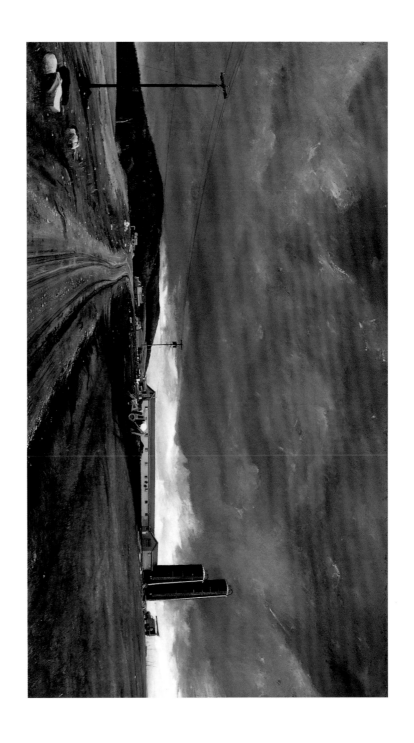

PLATE 58

STUDY FOR PLOWED FIELDS, MINNESOTA 1987

Oil on panel, 19 1/2 x 30 1/2 in.

Private Collection

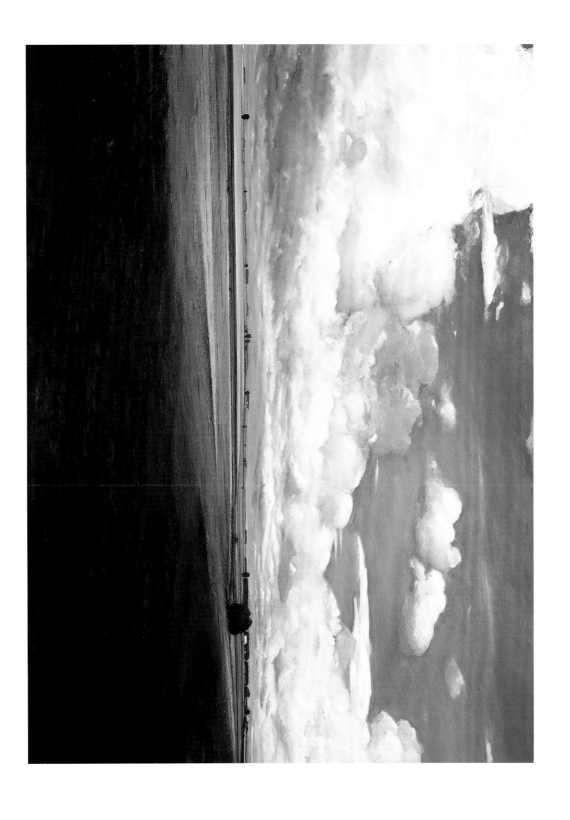

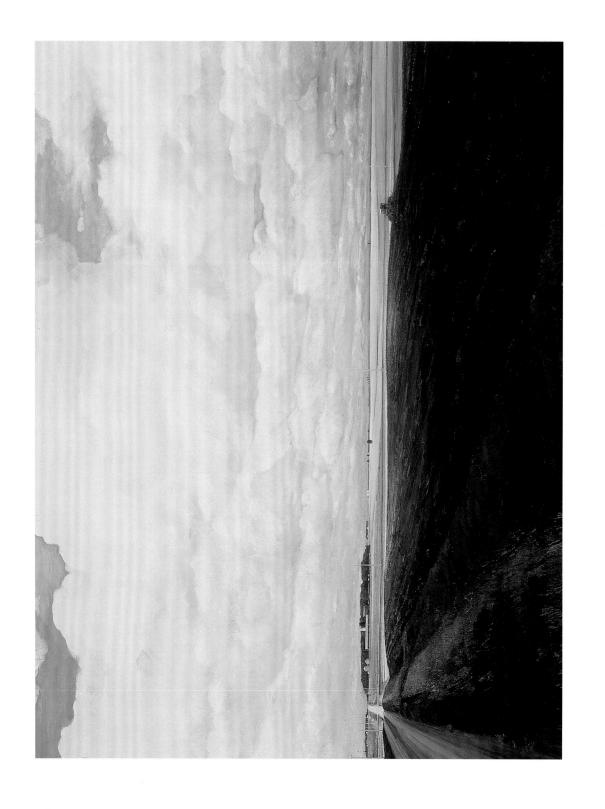

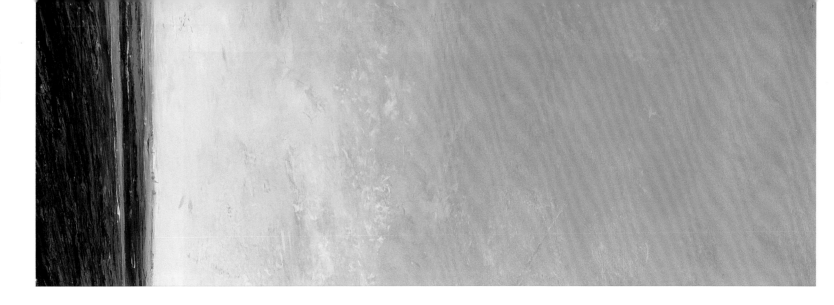

PLATE 61

MAYNARD, MINNESOTA 1986

Oil pastel on paper, 40 1/4 x 72 in.

Collection of Pacific Telesis, San Francisco

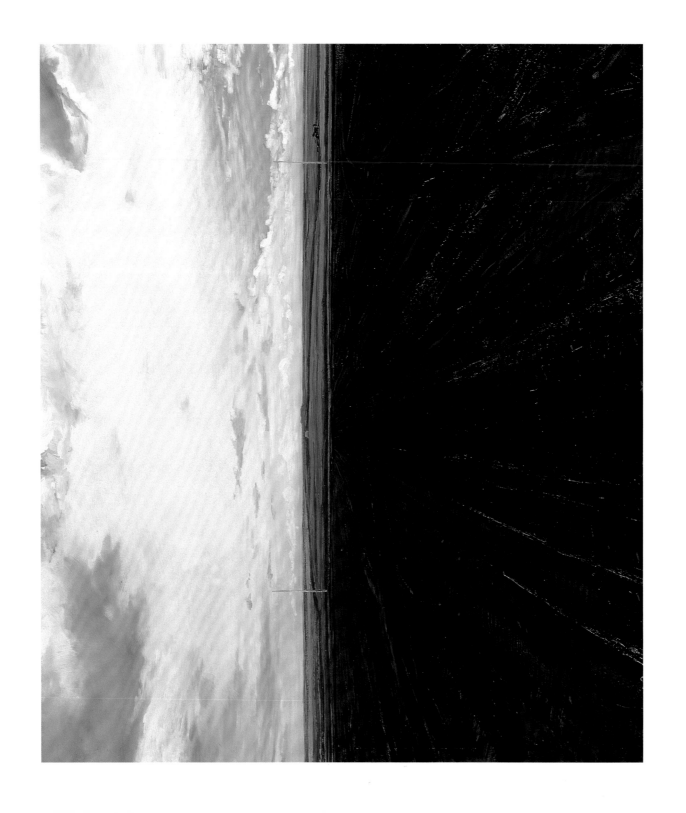

PLATE 64

DAKOTA 1999

Oil on panel, 25 1/2 x 29 1/2 in.

Collection of Rob and Marcie Orley, Michigan

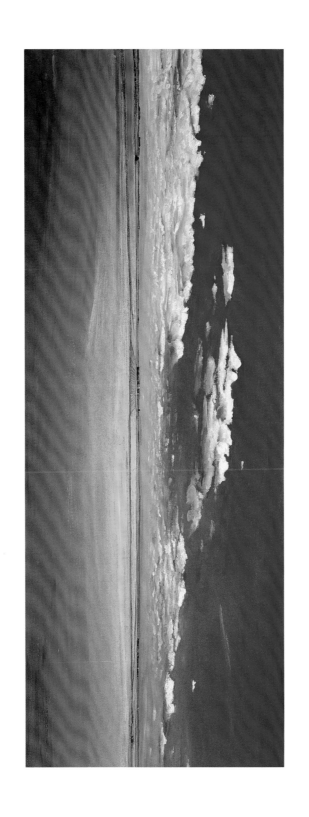

PLATE 65

GREAT PLAINS DAKOTA, MINNESOTA 1999

Oil on wood, 20 1/2 x 54 in.

Courtesy of Forum Gallery, New York

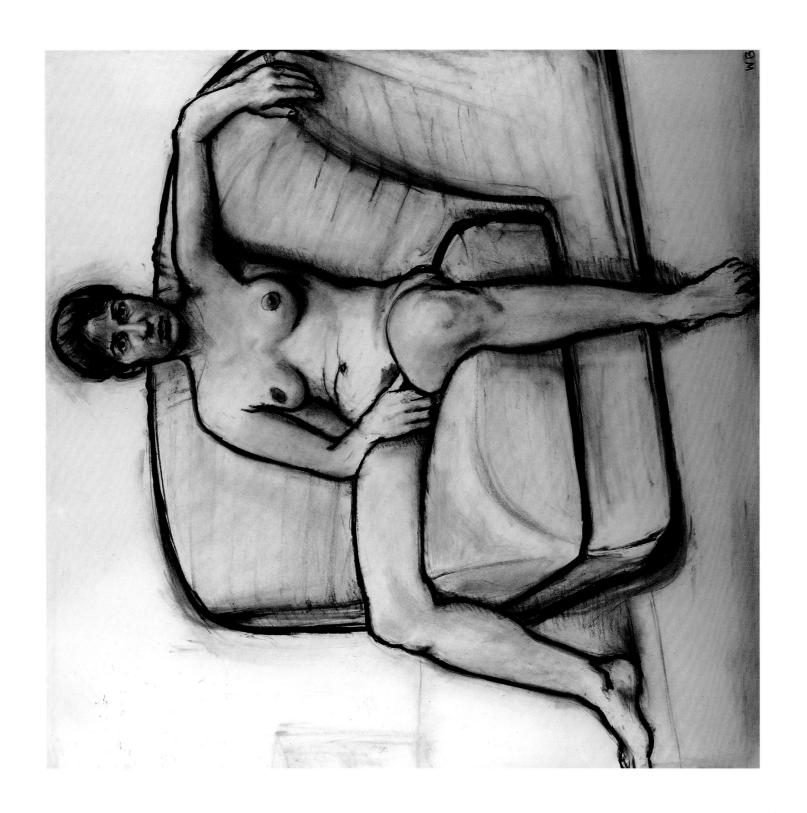

PLATE 66

CLASSICAL WOMAN #6 1988

Charcoal on paper 73 x73 in.
Collection of Stiebel, Ltd., New York

DRAWINGS AND STUDIES

AN ARTIST'S DRAWINGS AND STUDIES ARE USUALLY LOOKED UPON AS PROVIDING a behind-the-scenes glimpse at the creative process, revealing a first idea for a painting, perhaps, or a trial of its composition, or maybe a refinement of one of its parts—a hand, for instance, or a passage of drapery. In this view, they constitute practice or training, which means they serve an end outside themselves, like running one hundred miles a week with the purpose of running a marathon. Broadly speaking, this view applies to the Old Masters. In the modern, drawings and studies continue to pleasure as revelations of the creative process—they've lost none of that intimacy—but they've increasingly become ends in themselves, valued as complete statements independent of whatever else the artist might produce. What we particularly value, I think, is our sense of the genre's freedom. It offers a refuge from self-consciousness, it represents a place where experimentation is encouraged and play allowed, where process is its own reward—thus essentializing what is true of modern art generally. Yet, despite its appeal, which includes the fact that it's comprised of unique handmade objects, the genre in many ways remains under-appreciated. Drawings and studies can look casual, they're not often physically imposing, and their supports equate with fragility, requiring for them special care. Overall, they fight an uphill battle with painting and sculpture for major status.

Beckman's drawings and studies address all of these issues—some are preparatory, others ends in themselves, and more than a few challenge our preconceptions regarding the genre as a whole. But they overlap in doing so, for they are not programmatically conceived; whatever his aim at any particular moment, Beckman loves to draw, to go into the studio, crank up the volume on his sound system—rock, not classical—pick up the charcoal, and go at a fresh sheet of paper. In some cases, a very large sheet, seven or eight feet high, big enough to set his whole body in motion, like a workout. The energy shows—in the dense, sometimes strident black masses, in the sweep of a line contouring an entire body and sculpting it decisively from its surrounding space, in the overall expressionism that surprisingly reveals a whole other side of the artist's creative personality. In their physical size and the scale of their markings, drawings such as *Study for Woman and Man* (1987) PLATE 71, *Classical Woman #6* (1988) PLATE 66, and *Overcoats #2* (1998) PLATE 67, not only challenge our preconceptions of their medium, they equally challenge painting, for they are in every sense *major* statements—and in this they have few parallels in the art of our time.

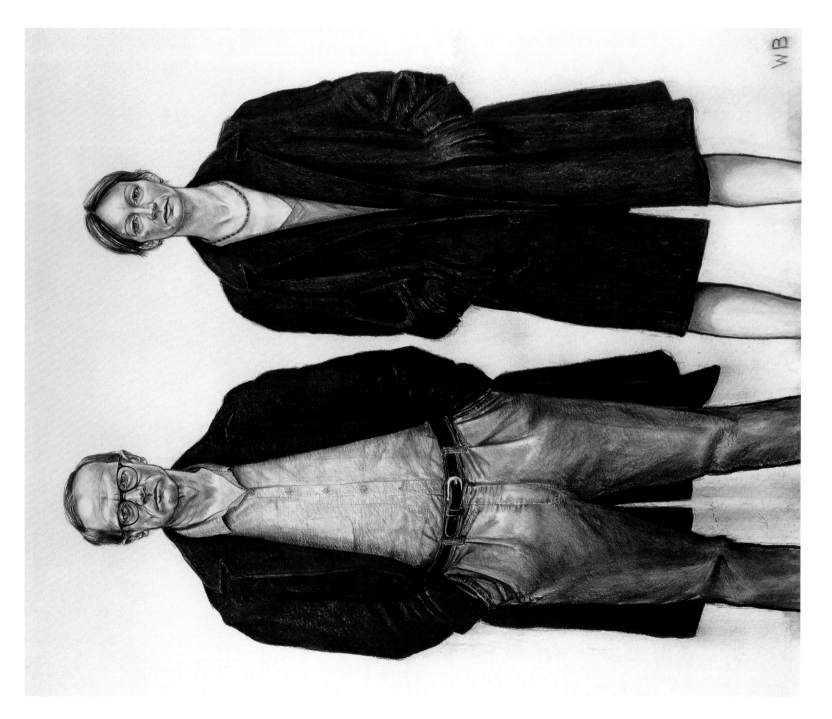

PLATE 67

OVERCOATS #2 1998

Charcoal on paper, 90 x 80 in.
Collection of Philip and Leticia Messinger

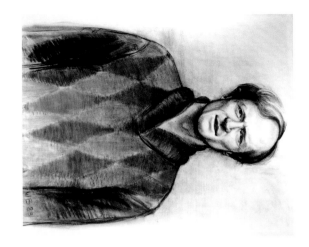

PLATE 68

SMILING SELF PORTRAIT 1983

Charcoal on paper, 42 1/2 x 33 in.

Private Collection

The drawings just cited can rightly be regarded as ends in themselves, but they were also preparatory, each leading to a major painting, among which Overcoats appears to have presented the stiffest obstacles to resolution. We see the initial conception in a 1988 oil study called *Overcoats #1* PLATE 27 that shows the artist on the left, standing and clothed, and his wife Diana on the right, seated and naked. That particular Diana seems to have evolved into the painting, *Diana #9* (1990) PLATE 18, where her image is similarly composed, with only the position of her hands changed. In any case, she is replaced in *Overcoats #2* (1989) PLATE 67 by a blurred, unidentifiable female figure who stands on the right, now fully dressed. This is a wonderful, altogether personal study, the freshness of its color and execution providing poignant contrast to the artist's introspective withdrawal and his partner's anonymity. With its (in)completion, the over-coats project nonetheless became suspended for nearly a decade until it reemerged in two masterful drawings, *Overcoats #1* (1997) PLATE 29 and *Overcoats #2* (1998) PLATE 67, both of which closely approximate the final painting and were clearly done in tandem with its development—thus, once more both preparatory and ends in themselves. But why the gap in the development of this theme? It can be explained in part by Beckman's concentration on two other ambitious paintings—and related drawings—undertaken in sequence when *Overcoats #2* was shelved, *Classical Woman* and *White Painting* which together absorbed him until well into the 1990s. But, as noted earlier, the hiatus also had to do with finding the right model for Overcoats, as though its conception had taken on a life of its own and needed to await her arrival. That, too, is suggested by these drawings and their chronology, and they assume added significance as a result, for, in documenting what he looked at and rendered, they additionally reveal how he thought and felt.

A few of the drawings seem to have been conceived entirely as ends in themselves, with no painting or other project in mind. From lusty figure studies to refined and delicate portraits, they demonstrate Beckman's full graphic range, and my personal favorite is the self portrait in which we see him smiling PLATE 68. Knowing Bill, I can assure you he smiles as much as anyone. Though I have to admit I'd be hard-pressed to find smiles in any of his pictures except this one—and the one of his mother, who he's told me was always smiling PLATE 78 to begin with. His enterprise, which deals so convincingly with modern relationships—with one another, with the landscape around us—that are by definition problematic in nothing if not serious, and his art is accord-ingly solemn and meditative. In forging it, at the same time, he's earned our ongoing respect and admiration as one of the finest artists our culture has produced—no easy task in a largely cynical world, yet surely cause for a moment of gracious, smiling satisfaction. **CB**

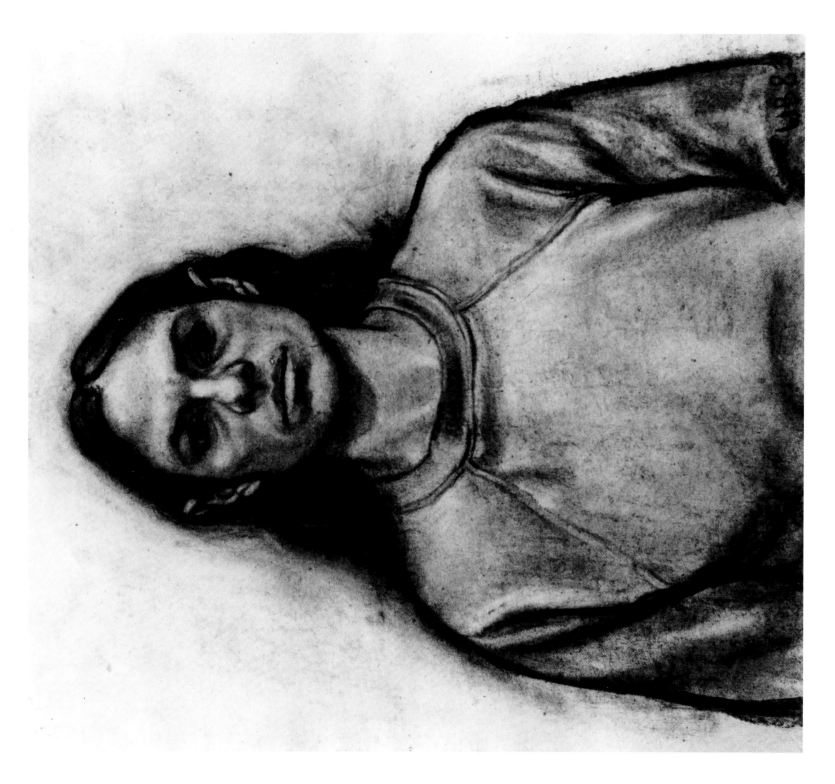

PLATE 69

PORTRAIT OF DIANA IN SWEATSHIRT 1983

Charcoal on paper, 30 x 25 in.
Private Collection

PLATE 70

SELF PORTRAIT IN THE STUDIO 1984

Charcoal on paper, 60 3/8 x 96 in.
Collection of Milwaukee Art Museum
Gift of the American Academy and Institute of Arts and Letters
Hassam Speicher Purchase Fund

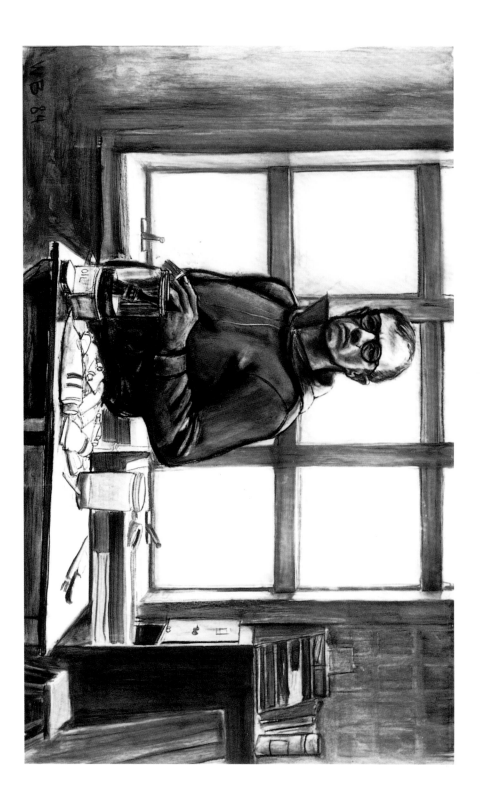

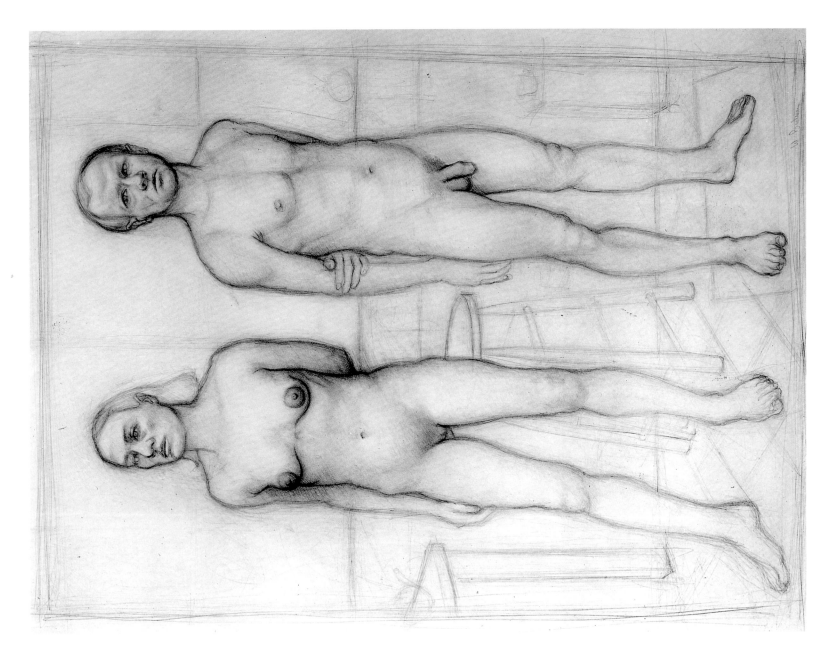

PLATE 71

STUDY FOR WOMAN AND MAN 1988

Pencil on paper, 28 1/2 x 20 1/2 in.
Collection of Stiebel, ltd.

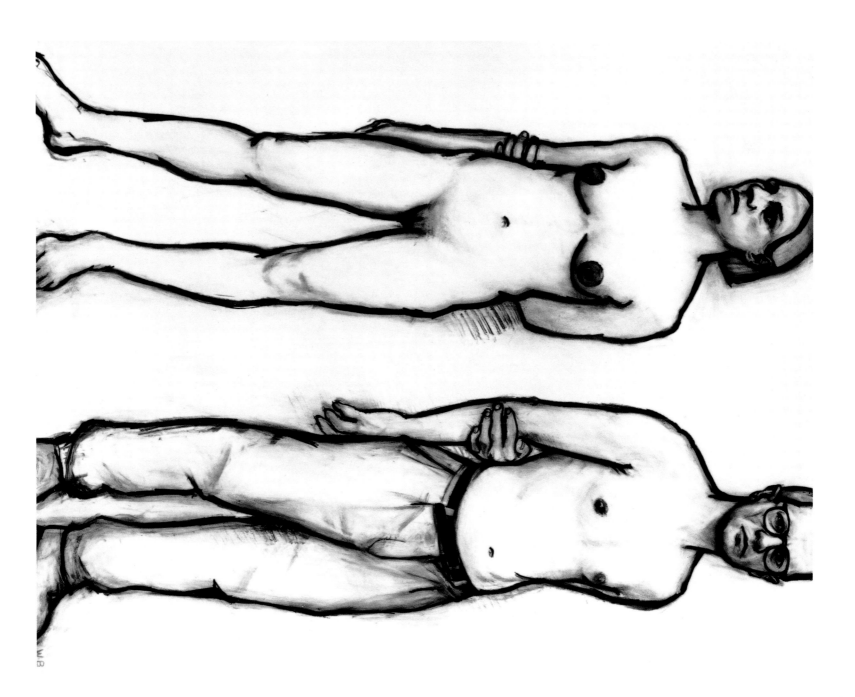

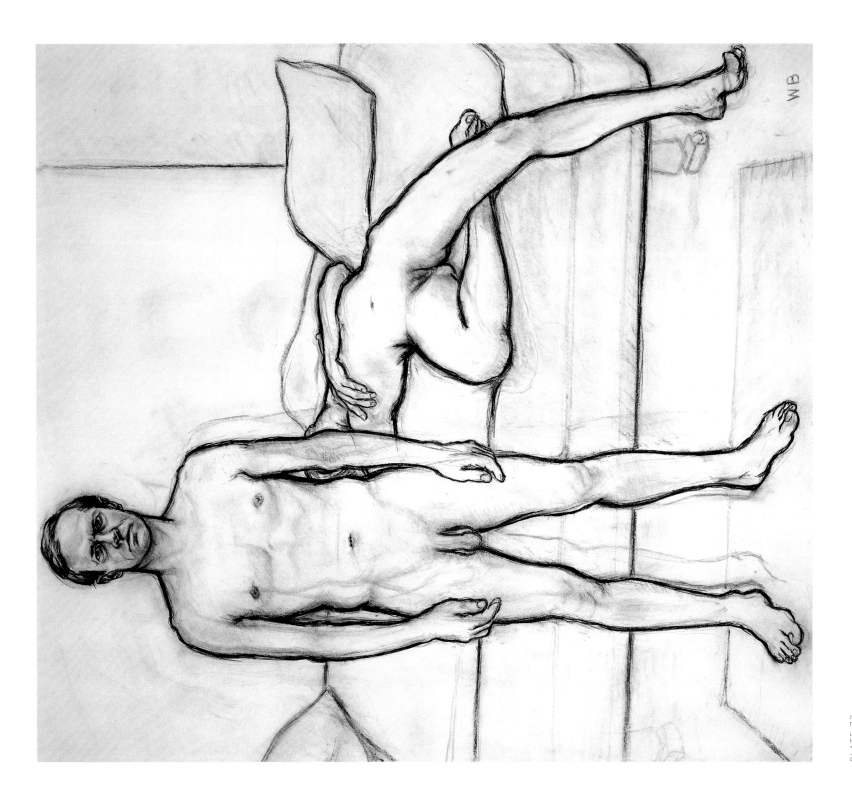

PLATE 73

BED STUDY 1991

Charcoal on paper, 90 x 80 in.
Courtesy of Forum Gallery

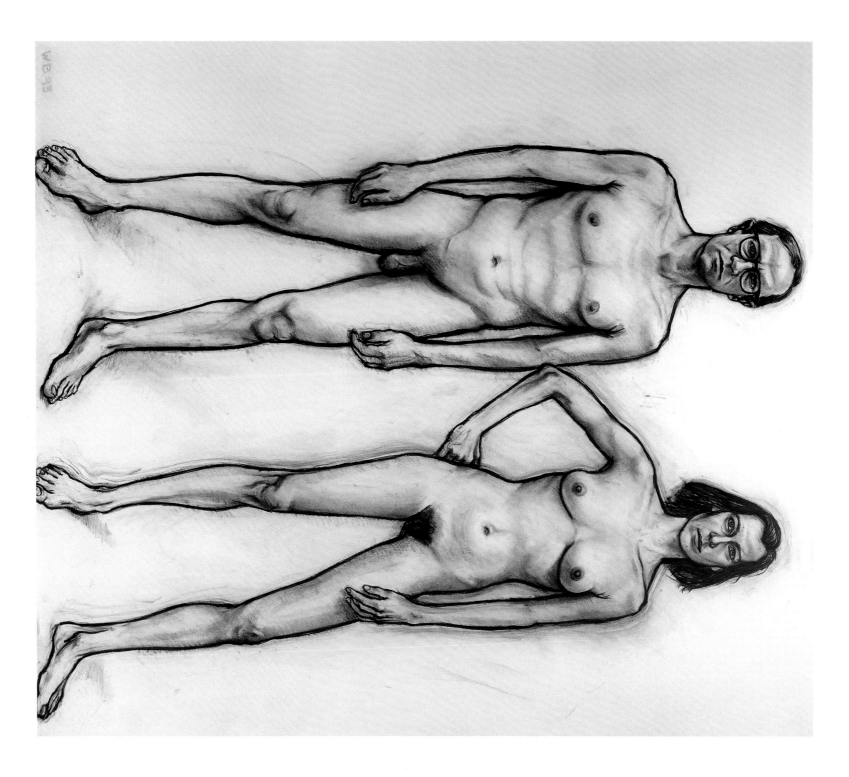

PLATE 74
STUDY FOR RED PAINTING 1993
Charcoal on paper, 90 x 80 in.
Courtesy of Forum Gallery

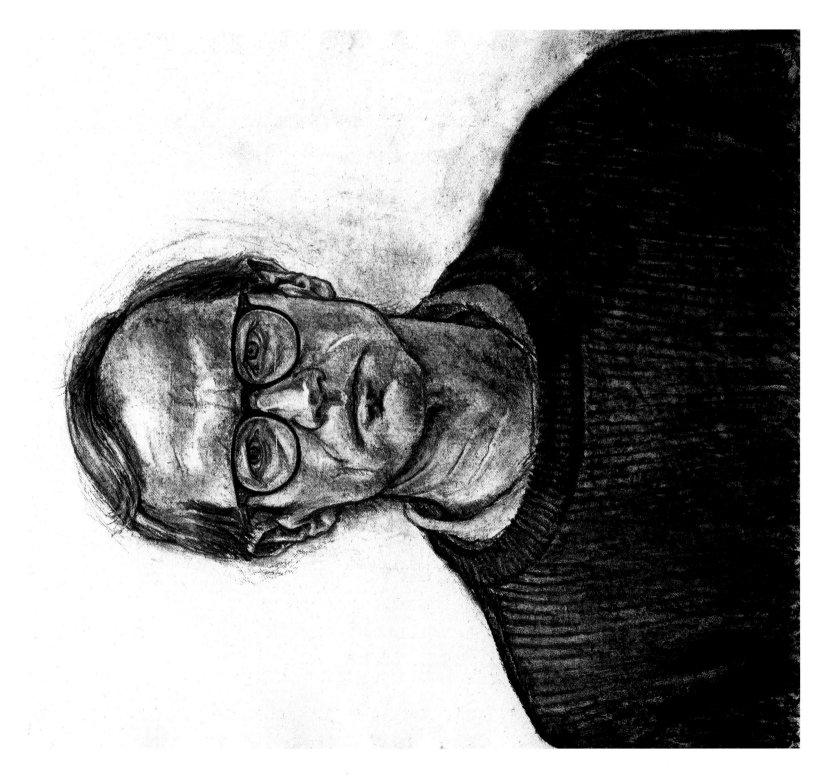

PLATE 75

SELF PORTRAIT (WITH BLACK SWEATER) 1997

Charcoal on paper, 29 x 24 in.
Private Collection

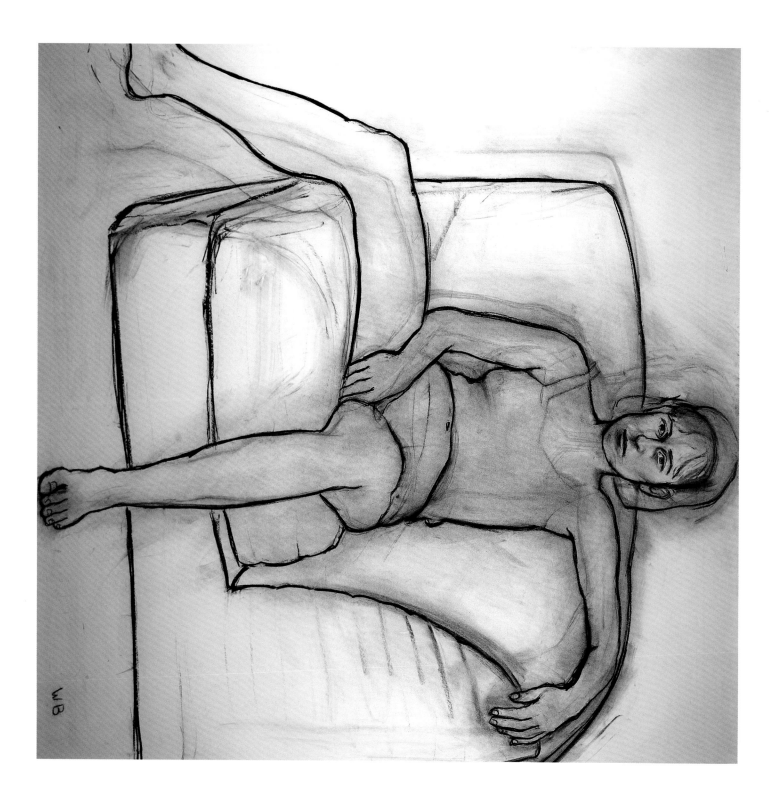

PLATE 76

CLASSICAL WOMAN #1 1988

Charcoal on paper, 80 x 80 in.
Collection of Anton and Betty Mason

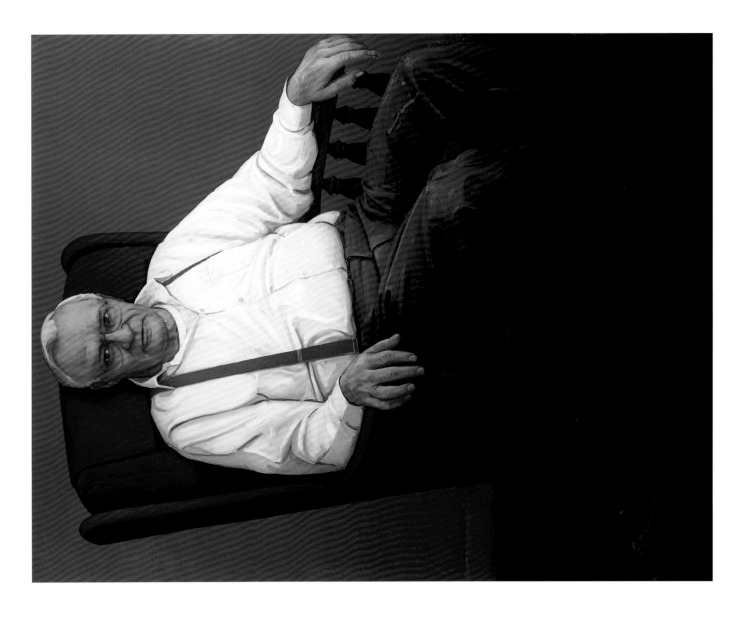

PLATE 77

MY FATHER 1988–1993

Oil on panel, 73 x 57 1/4 in.
Collection of Frye Art Museum

92

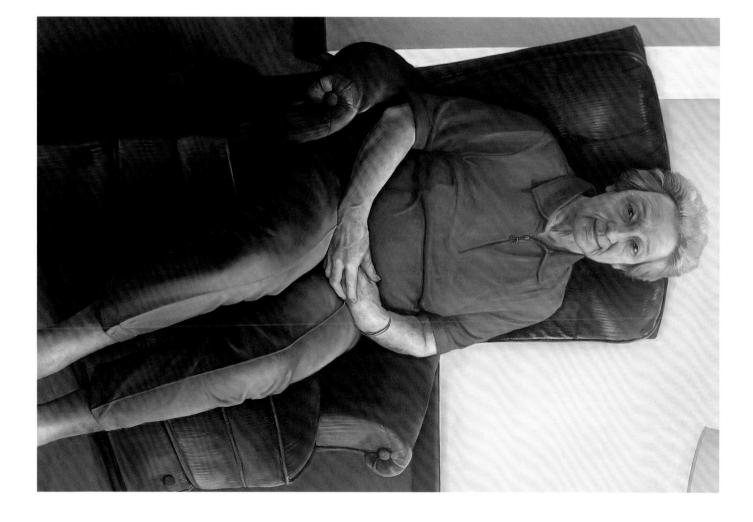

PLATE 78

MY MOTHER 2000

Oil on panel, 72 x 49 1/4 in.

Collection of Frye Art Museum

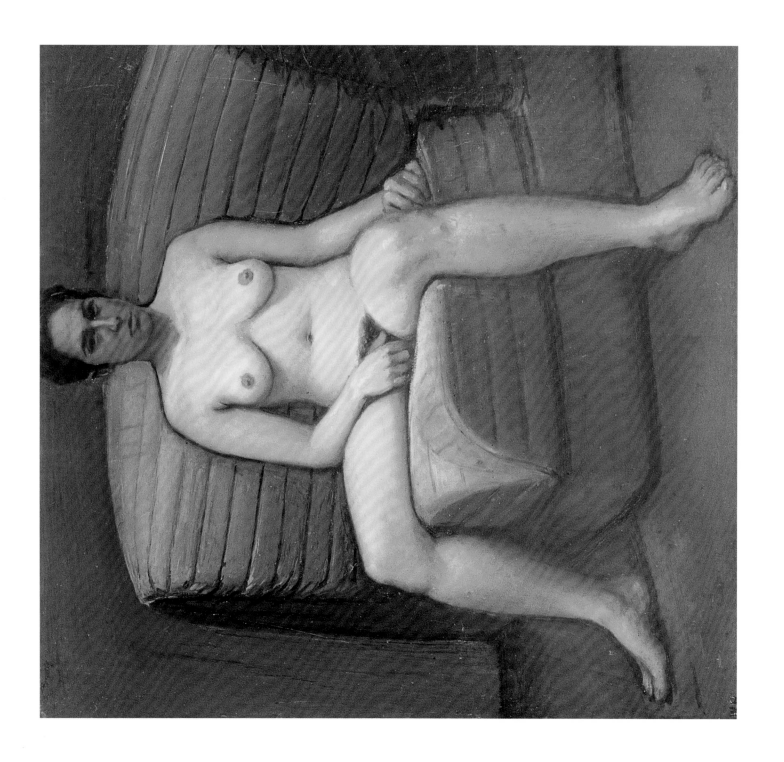

PLATE 79

STUDY FOR CLASSICAL WOMAN 1989

Oil on panel, 15 x 14 1/4 in.
Collection of Rick and Monica Segal

94

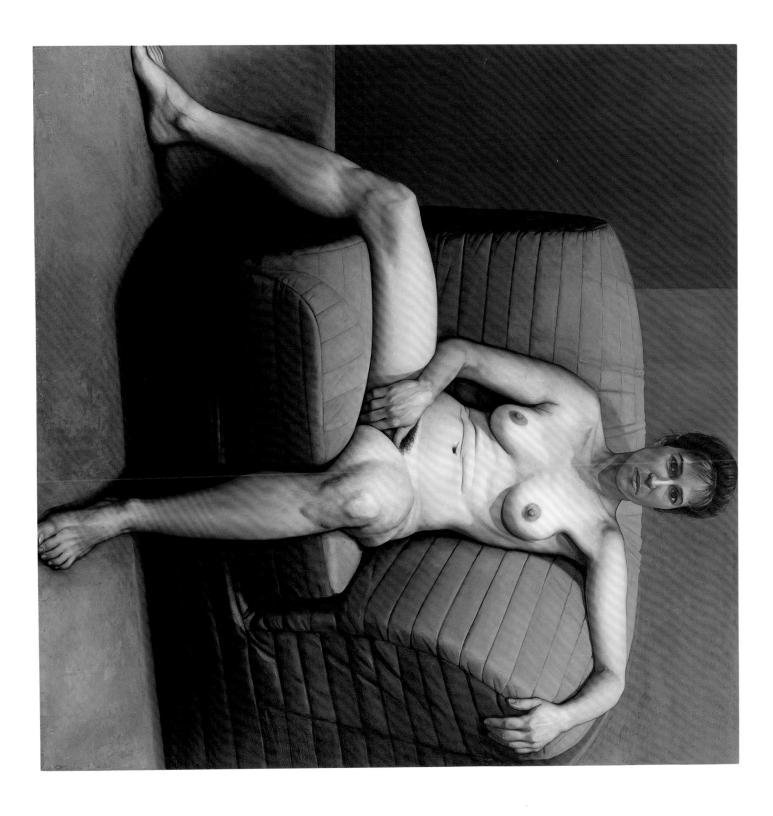

PLATE 80
CLASSICAL WOMAN 1989–1990
Oil on panel, 80 x 80 in.
Private Collection

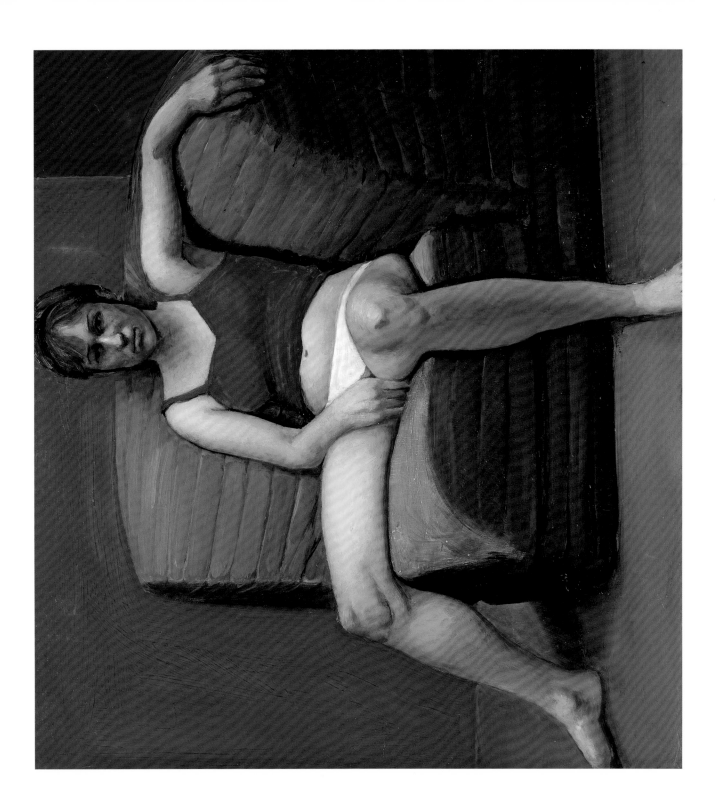

PLATE 81

CLASSICAL WOMAN, WOMAN CLOTHED 1989

Oil on panel, 14 1/2 x 15 5/8 in.

Private Collection, New Jersey

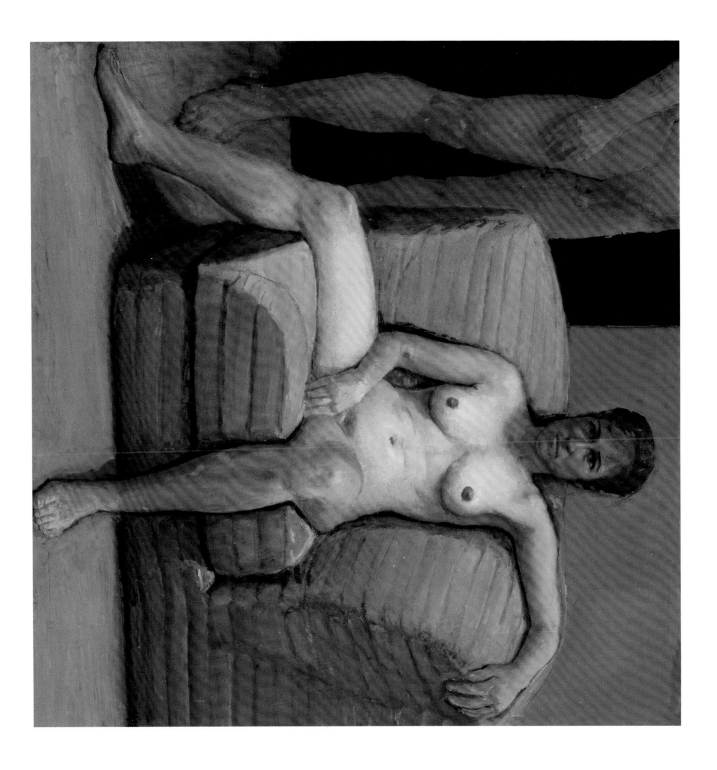

PLATE 82

CLASSICAL WOMAN, WOMAN AND STANDING MAN 1989

Oil on panel, 15 1/2 x 15 in.

Robinson Family Collection, Miami, Florida

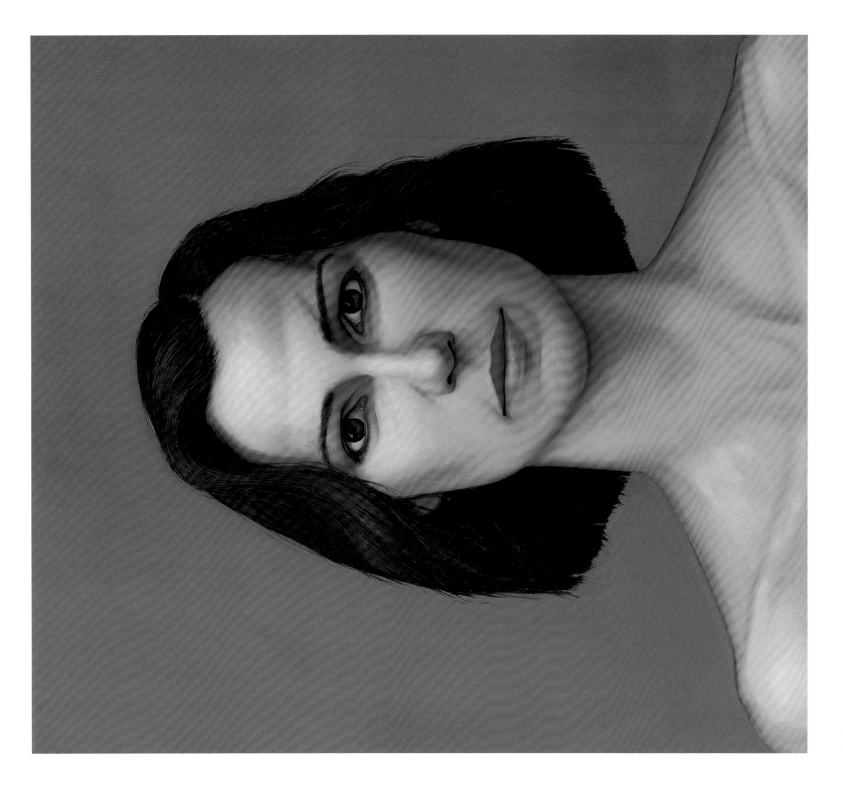

PLATE 83

DEBORAH #1 1993–1994

Oil on panel, 20 5/8 x 18 3/8 in.

Collection of Dr. Thomas A. Mathews

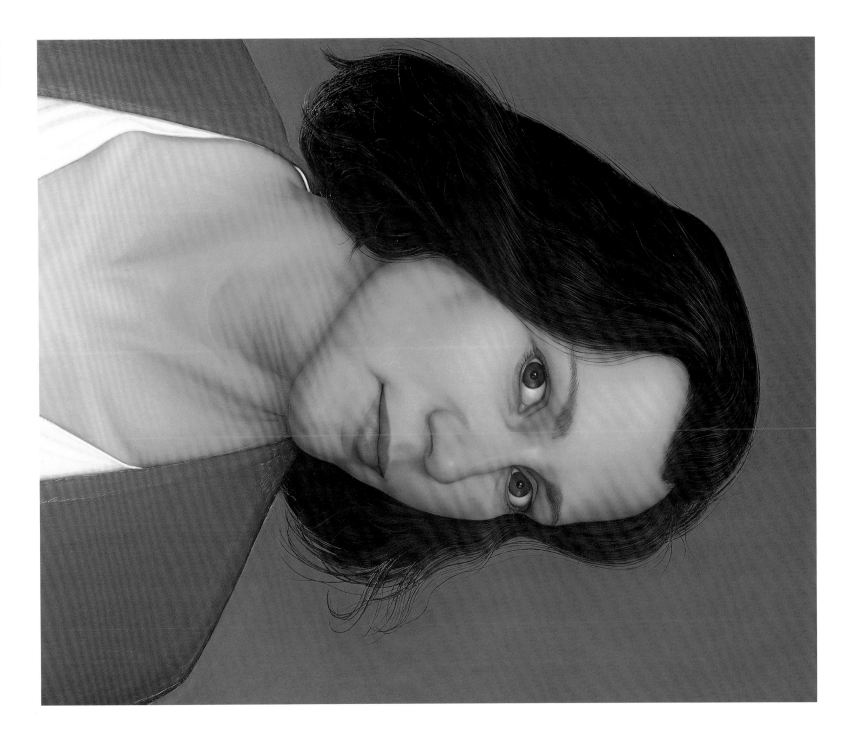

PLATE 84

DEBORAH #2 (WITH RED SWEATER) 1994

Oil on panel, 17 7/8 x 15 in.
Collection of Rick and Monica Segal

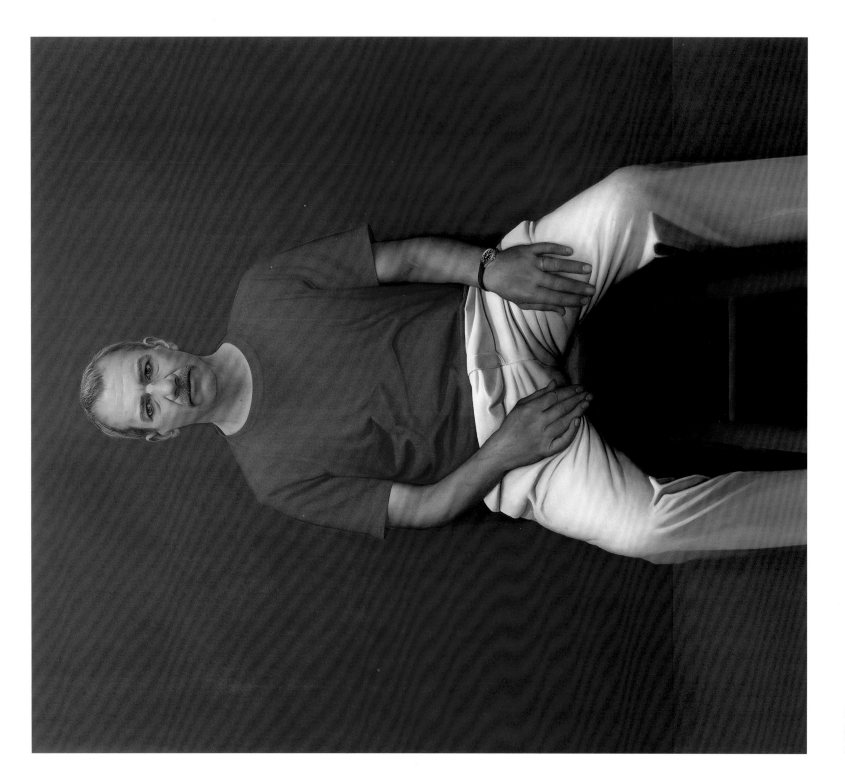

PLATE 85

PORTRAIT OF GREGORY GILLESPIE 1995

Oil on panel, 72 x 60 in.
Courtesy of Forum Gallery

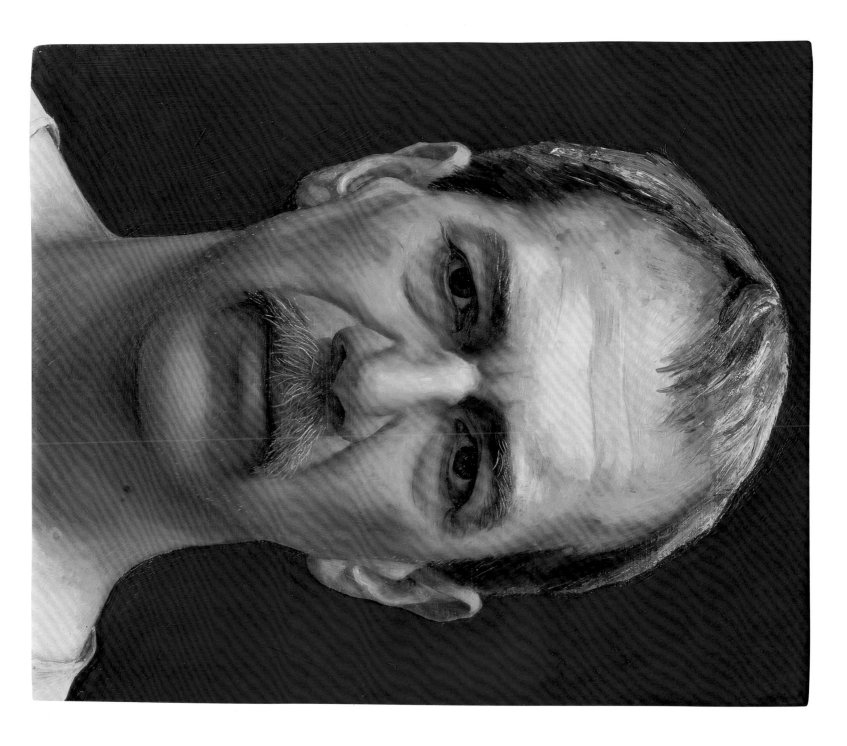

PLATE 86

PORTRAIT OF GREGORY GILLESPIE 1996

Oil on panel, 14 x 11 1/2 in.
Collection of Thomas J. Huerter

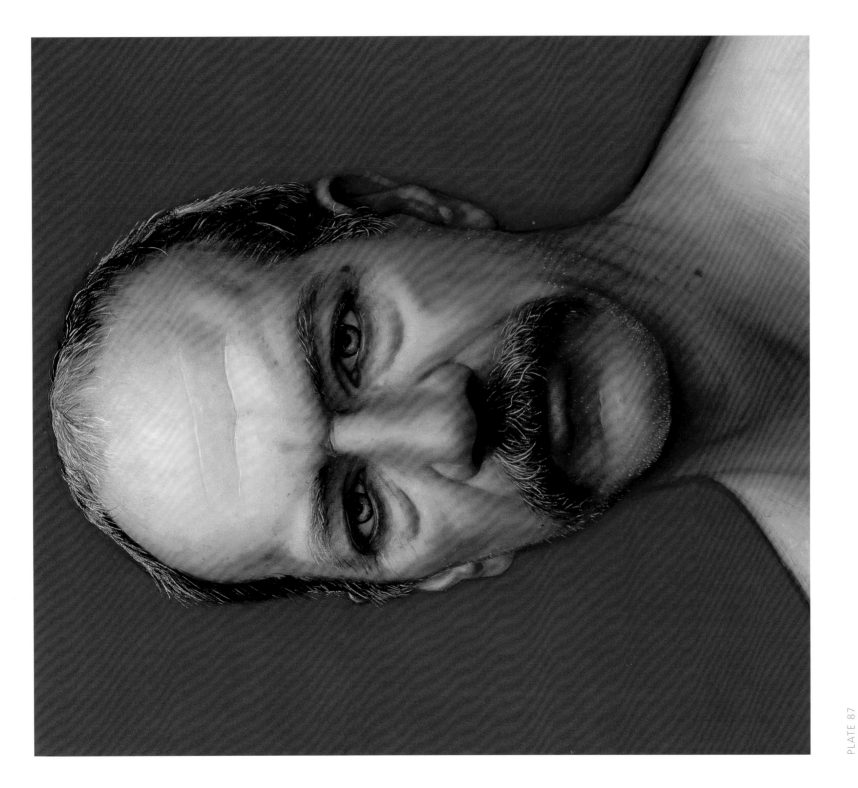

PLATE 87

PORTRAIT OF GREGORY GILLESPIE 2000

Oil on panel, 16 3/16 x 15 5/8 in.
Collection of Seven Bridges Foundation

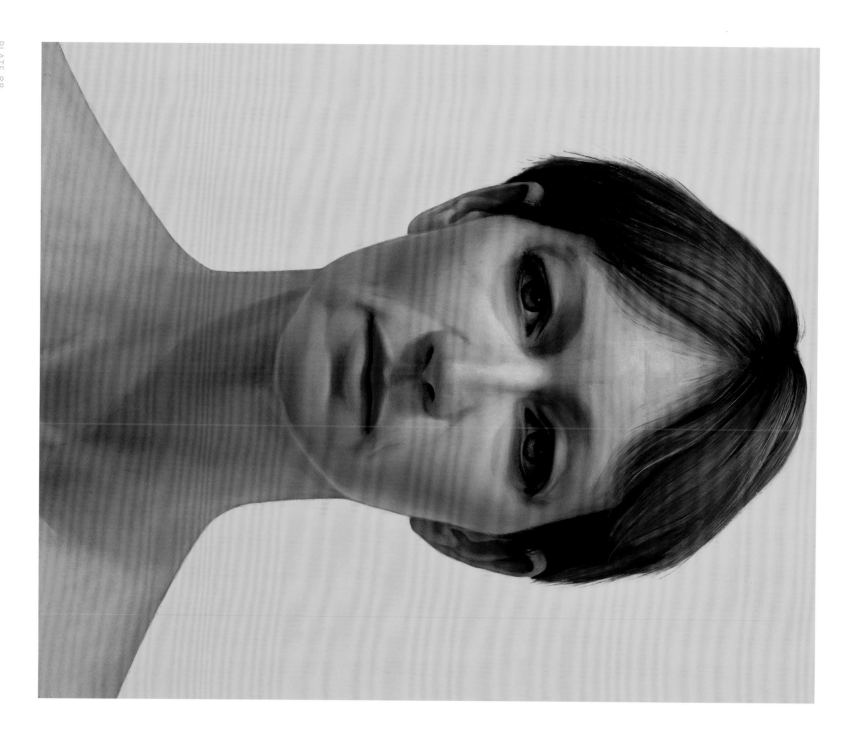

PLATE 88

JEANNIE #1 1996
Oil on panel, 14 x 11 1/2 in.
Private Collection

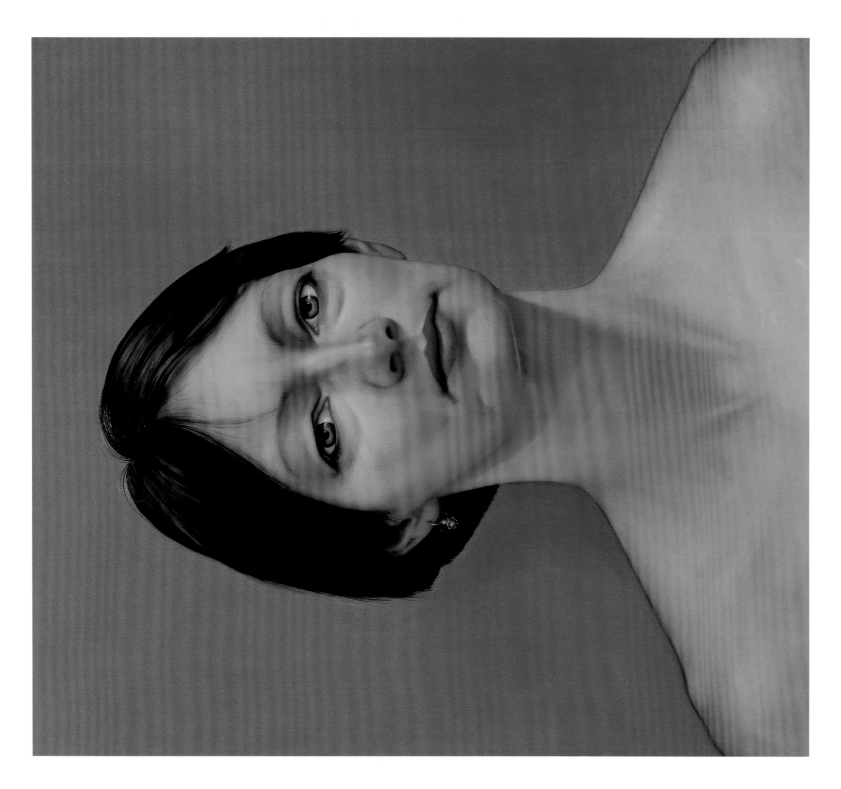

PLATE 89

JEANNIE #2 1998

Oil on panel, 20 1/2 x 18 1/4 in.
Collection of Rob and Marcie Orley

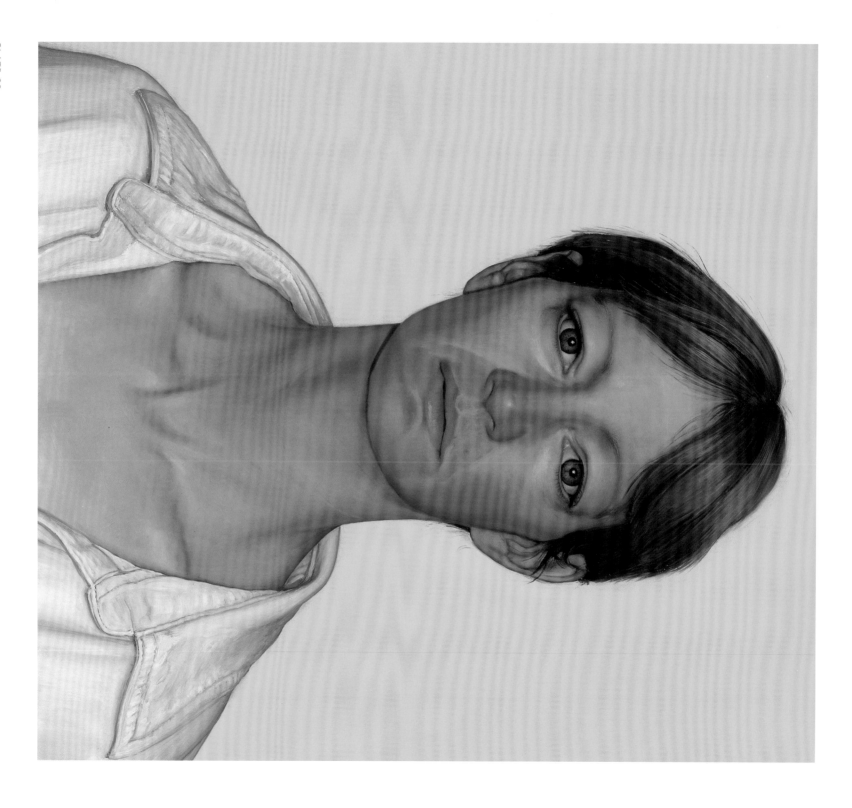

SELECTED BIOGRAPHY

BORN

1942 Maynard, MN

EDUCATION

1966 BA, St. Cloud State University, St. Cloud, MN

1968 MA and MFA, University of Iowa, Iowa City, IA

SELECTED ONE PERSON EXHIBITIONS

2002 *Painting on the Edge*, Frye Art Museum, Seattle, WA (catalogue)

2001 Forum Gallery, Los Angeles, CA (catalogue)

1999 *Figure Drawing*, Huntington Museum of Art, Huntington, West Virginia

1997 Forum Gallery, New York, NY (catalogue)

1996 K & E Gallery, New York, NY

1994 Forum Gallery, New York, NY (catalogue)

1992 *Dossier of a Classical Woman*, Stiebel Modern, New York, NY; Indiana University Art Museum, Bloomington, IN (catalogue)

1989 Allan Frumkin, New York, NY

1988 Allan Frumkin, New York, NY

1986 Allan Frumkin, New York, NY (catalogue)

1985 Allan Frumkin, New York, NY

1982 Allan Frumkin, New York, NY (catalogue)

1980 Allan Stone, New York, NY

1978 Allan Stone, New York, NY

1976 Allan Stone, New York, NY

1974 Allan Stone, New York, NY

1971 Allan Stone, New York, NY

1970 Allan Stone, New York, NY

1969 Hudson River Museum, Yonkers, NY

PLATE 91

SELF PORTRAIT 1983

Charcoal on paper, 30 x 25 in.

Collection of Jalene and Richard Davidson

SELECTED GROUP EXHIBITIONS

2002

Perception of Appearance: A Decade of Contemporary American Figure Drawing, Frye Art Museum, Seattle, WA (catalogue)

2001

Landscape 2001, University of Wyoming Art Museum, Laramie, WY

Self-Made Man, DC Moore Gallery, New York, NY

Identities: Contemporary Portraiture, New Jersey Center for Visual Arts, Summit, NJ

2000

Collecting Ideas: Works from the Mark and Polly Addison Collection, Denver Art Museum, Denver, CO

Drawings by 20th Century and Contemporary Masters, Forum Gallery, New York, NY

1999

The Nude in Contemporary Art, Aldrich Museum of Contemporary Art, Ridgefield, CT

Contemporary American Realist Drawings, Jalene and Richard Davidson Collection, The Art Institute of Chicago, Chicago, IL

Drawn Across the Century: Highlights from the Dillard Collection of Art on Paper, Weatherspoon Art Gallery, University of North Carolina, Greensboro, NC

Figure Drawing, Huntington Museum of Art, Huntington, WV

Green Woods and Crystal Waters: The American Landscape Tradition, Philbrook Museum of Art, Tulsa, OK

National Academy of Design: 174th Exhibition, National Academy of Design, New York, NY

1998

The Figurative Impulse, Miami Dade Community College, Kendall Campus Art Gallery, Miami, FL

Drawing the Figure: Kent Bellows and William Beckman, Forum Gallery, New York, NY

1997

Landscape, Seen and Unseen, Pratt Manhattan Gallery and the Rubelle and Norman Schafler Gallery, New York, NY

1996

Paint Counterpaint: Portraits of and by William Beckman and Gregory Gillespie, The Frances Lehman Loeb Art Center, Vassar College, Poughkeepsie, NY

Reinventing Realism: Contemporary American Perspectives, Everhardt Museum, Scranton, PA

1995

Visiting Artist Series, Holtzman Gallery, Towson State University, Towson, MD

1994

The Body Human, Nohra Haime Gallery, New York, NY

169th Annual Exhibition, National Academy of Design, New York, NY

1993

20th Century Figurative Drawings and Paintings, Forum Gallery, NY

Drawings of the Figure, Carlsten Art Gallery, University of Wisconsin, Stevens Point, WI (catalogue)

1991

American Realism and Figurative Art, 1952–1990, Miyagi Museum of Art, Sendai, Miyagi, Japan; Sogo Museum of Art, Yokohama, Japan; Tokushima Modern Art Museum, Tokushima, Japan; Museum of Modern Art, Shiga, Japan; Kochi Prefectural Museum of Folk Art, Japan (catalogue)

45th Annual Purchase Exhibition, Academy of Arts and Letters, New York, NY

1987

Ten at the Rose, Rose Art Museum, Brandeis University, Waltham, MA (catalogue)

1986

An American Renaissance, Ft. Lauderdale Museum of Art, Ft. Lauderdale, FL (catalogue)

American Realism: Twentieth-Century Drawings and Watercolors from the Collection of Glenn Janss, San Francisco Museum of Modern Art, CA; DeCordova and Dana Museum, Lincoln, MA; Huntington Art Gallery, University of Texas, Austin; Block Gallery, Northwestern University, Evanston, IL; Williams College Museum of Art, Williamstown, MA; Akron Art Museum, OH: Madison Art Center, WI (catalogue)

1985

Drawings Acquisitions, Whitney Museum of American Art, New York, NY

American Realism: The Precise Image, Isetan Museum of Art, Tokyo, Japan; Diamaru Museum, Osaka, Japan; Yokohama Takashimaya, Japan (catalogue)

PUBLIC COLLECTIONS

Arkansas Art Center, Little Rock, AR

The Art Institute of Chicago, IL

Carnegie Museum of Art, Pittsburgh, PA

Des Moines Art Center, IA

Flint Institute of Arts, MI

Frye Art Museum, Seattle, WA

Hirshhorn Museum and Sculpture Garden, Washington, DC

Milwaukee Art Museum, WI

Museum Moderne Kunst, Vienna, Austria

New Britain Museum of American Art, CT

Rose Art Museum, Brandeis University, Waltham, MA

Smith College Museum of Art, Northampton, MA

Weatherspoon Art Gallery, University of North Carolina, NC

Whitney Museum of American Art, NY

Yale University Art Gallery, New Haven, CT

AWARDS AND ALLIANCES

1999　National Academy of Design, the Thomas R. Proctor Prize

1995　American Academy of Arts and Letters Purchase Award

1990　American Academy of Arts and Letters Purchase Award

1987　American Academy of Arts and Letters Purchase Award

1985　American Academy of Arts and Letters Purchase Award

1969　Figurative Alliance

1984　*Beckman/Gillespie*, Rose Art Museum, Brandeis University, Waltham, MA; La Jolla Museum of Contemporary Art, CA (catalogue)

1983　*American Super-Realism from the Morton S. Neuman Family Collection*, Terra Museum of American Art, Chicago, IL (catalogue)

1982　*Focus on the Figure*, Whitney Museum of American Art, New York, NY (catalogue)

Perspectives on Contemporary American Realism: Works on Paper from the Collection of Jalene and Richard Davidson, The Art Institute of Chicago; Pennsylvania Academy of the Fine Arts, Philadelphia, PA (catalogue)

1981　*Directions 1981*, Hirshhorn Museum and Sculpture Garden, Washington, DC (catalogue)

Americkansche Malerei, Haus der Kunst, Munich, Germany

Inside Out: Self Beyond Likeness, Newport Harbor Art Museum, Newport Beach, CA; Portland Art Museum, OR; Joslyn Art Museum, Omaha, NE

Contemporary American Realism Since 1960, Pennsylvania Academy of the Fine Arts, Philadelphia, PA; Virginia Museum of Fine Arts, Richmond; Oakland Museum, CA; Gulbenkean Museum, Lisbon, Portugal; Kunsthalle, Nuremberg, Germany (catalogue)

1975　*Modern Portraits: The Self and Others*, Wildenstein & Co., New York, NY (catalogue)

1974　*American Portrait Drawings*, National Portrait Gallery, Washington, DC (catalogue)

Seventy-First American Exhibition, The Art Institute of Chicago, Chicago, IL (catalogue)

Aspects of the Figure, Cleveland Museum of Art, Cleveland, OH (catalogue)

Art Conceptuel et Hyperrealiste: Collection Ludwig, Musee d'Art Moderne de la Ville de Paris, France; Neue Gallerie, Aix-la-Chapelle, France (catalogue)

1968　*Seven Young Talents from Iowa*, Richard Feigen Gallery, Chicago, IL